blue
rider
press

By the same author

Feelings and Moods

LOOKING AT

MINDFULNESS

25 ways to live in the moment through art

CHRISTOPHE ANDRÉ

Translated by Trista Selous

BLUE RIDER PRESS
a member of Penguin Group (USA)
New York

blue
rider
press

Published by the Penguin Group
Penguin Group (USA) LLC
375 Hudson Street
New York, New York 10014

USA · Canada · UK · Ireland · Australia
New Zealand · India · South Africa · China

penguin.com
A Penguin Random House Company

Originally published in France as *Méditer, Jour Après Jour* by L'Iconoclaste, Paris, in 2011

The English edition was first published in Great Britain as *Mindfulness* in 2014 by Rider,
an imprint of Ebury Publishing. Ebury Publishing is a Random House Group company.

Christophe André has asserted his right to be identified as the author of this work
in accordance with the Copyright, Designs and Patents Act 1988.

ISBN 978-0-399-17563-3

Printed in the United States of America
1 3 5 7 9 10 8 6 4 2

With grateful thanks

To Jon Kabat-Zinn for his vision,
To Zindel Segal for his knowledge,
To Matthieu Ricard for his example,

And to all three for
their teaching and friendship.

The miracle
is to walk on Earth.

Thich Nhat Hanh

L iving in mindfulness means paying regular, calm attention to the present moment. This attitude can radically alter our relationship to the world, ease our suffering and enhance our joys. Mindfulness is also a type of meditation. Its basic techniques are quick and simple to learn, but take years to master fully (like everything in life that matters to us).

To move toward mindfulness we must first understand what it is and how it is practiced. The words in this book offer insight into these things. We must then free ourselves from words in order simply to sense and feel, and the paintings will help with this. Lastly we must practice and experiment on our own. Advice and exercises are suggested throughout the pages that follow. The secrets of living in mindfulness can be summed up in three words: understand, feel and practice, over and over.

CONTENTS

3. PASSING THROUGH STORMS: THE PRESENT MOMENT AS A REFUGE

4. OPENING AND AWAKENING: THE GREATEST OF JOURNEYS

TAKING FLIGHT: UNIVERSAL AWARENESS

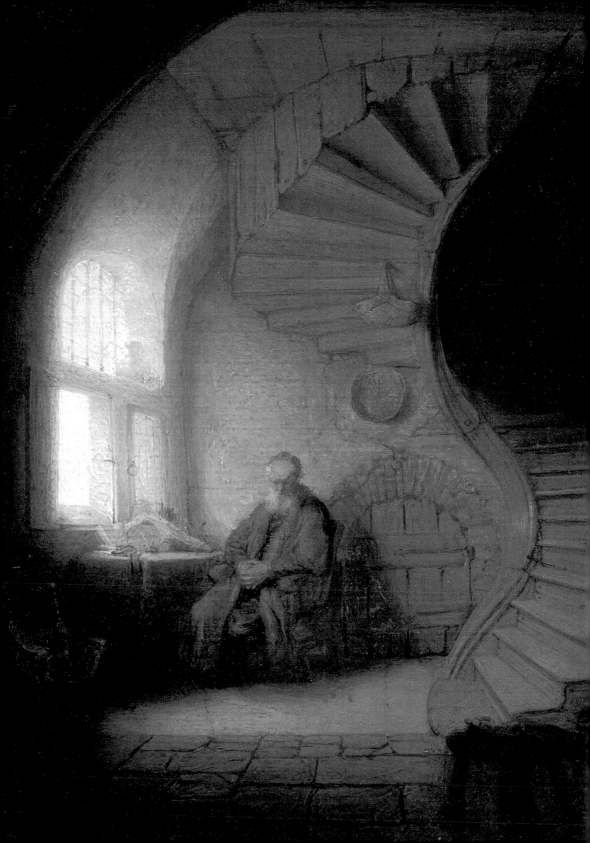

PRELUDE
PRESENCE, NOT EMPTINESS

Divinely I meditate
And I smile at all the beings
I have not created.

Guillaume Apollinaire, *Alcools* (trans. D. M. Black)

The first thing we see is the intense, yellow light of the winter sun outside—a sun that dazzles without warmth. Then we notice the old man sitting motionless, having turned away from his table and the book he was studying. Is he thinking? Resting? Meditating? We look to the right and notice the low cellar door, then our eyes are drawn to the spiral staircase, but we have barely registered its first few steps when we notice the fire crackling in the grate and the woman stoking it. Our eyes return to the staircase, but it leads only into darkness.

The painting is small, the place it depicts is dark, yet we have a sense of immense space. This is the genius of Rembrandt, who leads us on a visual journey through all the dimensions. We travel the painting widthways left to right, from the daylight pouring in to the fragile, almost derisory firelight. There's a dialogue established between the sun that lights but does not warm and the fire that warms but sheds no light. Are these the sun of reason and the fire of passion, two ingredients that combine in philosophy? We travel the painting's height by means of the spiral staircase that links the deep secrets of the cellar to the dark mysteries of the upper floor, and we travel its depth, from the background where the philosopher sits to the surrounding circle of shadows. But the sense of space

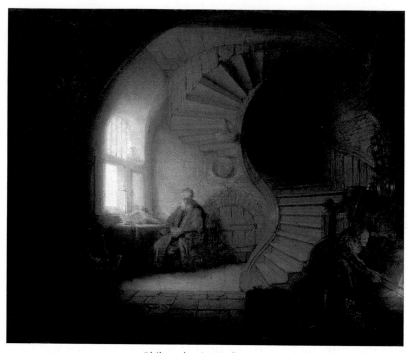

Philosopher in Meditation,
Harmensz Van Rijn, known as Rembrandt (1606–1669)
1632, oil on wood, 28 x 34 cm, Musée du Louvre, Paris

also derives from the subtle interplay between all that is revealed and all that is hidden, where our imagination is crucial—what lies on the other side of the window, behind the cellar door, at the top of the stairs? The largest of the worlds hidden from our restless eyes is the philosopher's mind, his inner world. Shadows and darkness, a little light, a little warmth and a working mind—is that what our inner selves are like?

Meditation means stopping

Stop doing, stop moving, stop twisting and turning. Meditation means withdrawing a little, stepping back from the world.

At first what we feel seems odd. There's an emptiness (no action or distraction) and a fullness (a tumult of thoughts and sensations that we suddenly notice). There's what we lack—points of reference and *things to do*—and, after a little while, there's the calm this lack brings. Things here are not the same as they are "outside," where our mind constantly attaches itself to some aim or project, acting or thinking about something in particular, having its attention held by some distraction.

The apparent inaction of the experience of meditating takes a little while to get used to. As in Rembrandt's painting, or when we move from light to shadow, we don't see clearly straightaway. We have gone inside ourselves, for real. Our inner world was close by, but we never went there. We tended to hang around outside; in today's world of frantic demands and frenzied connections, our relationship to ourselves often goes untended. We abandon our inner world. The outside world is easier to travel and better signposted. To meditate is often to move through a land without paths. In the room where the philosopher is meditating there's less light, so you have to open your eyes wider. The same is true inside ourselves. There is less that is obvious or reassuring, so we must open our mind's eye much wider.

We expected—or hoped—to find calm and emptiness. We often find ourselves in a huge, rowdy, chaotic bazaar. We aspired to clarity, we find confusion. Sometimes meditation exposes us to anxiety and pain, to things that hurt us and that we have avoided by thinking about something else or busily doing things elsewhere.

Calming agitation

It all looked so simple from the outside! We thought it would be enough just to sit down and close our eyes. But no, that's just the start. It's indispensable, but not enough in itself. So what now? Now we have to work. We must learn to look, to remain slightly apart from the world, sitting just like this with closed eyes. We must learn to allow the tumult to settle.

The first thing to accomplish is no more than that, sitting still and quiet for long enough to allow a kind of calm to settle around the chatter of our mind, enough for us to start seeing a bit more clearly. We must not try to achieve it by force or will—that would only trigger more chaos. We must let it happen, let it come, from inside.

We have gone inside ourselves, for real. Our inner world was close by, but we never went there.

Sometimes we have to wait a long time. This process is not something that can be rushed. We would like to speed it up, but no, meditation takes time. In fact there are days when nothing comes at all. Which may come as a bit of a shock, and seem out of tune with times that promise us instant, guaranteed results. Zen wisdom has many tales to illustrate this point, such as the one about a student who asks his teacher, "Master, how long will I have to meditate to attain serenity?" After a long silence the master replies, "Thirty years." The student looks stricken. "Er . . . that's a very long time. What if I make twice the effort? What if I work really hard, day and night, and don't do anything else?" The teacher remains silent for a very long time and then says, "Then it will take you fifty years."

Starting to see more clearly

So we have stopped, we have sat down and closed our eyes. Not to sleep, not to rest, but to understand. We need to understand what we feel and put some order into the chaos that is simply the world's echo within ourselves. We must understand that there are two paths: the path of intelligence (acting, intervening, kneading reality with our will, lucidity and effort) and the path of experience (welcoming naked reality and allowing it to cover, inhabit and imbue us, in a movement of intensely attentive letting go).

Both intelligence and experience keep us in contact with the world, one enabling us to understand it better, the other to feel it better. Each in its own way

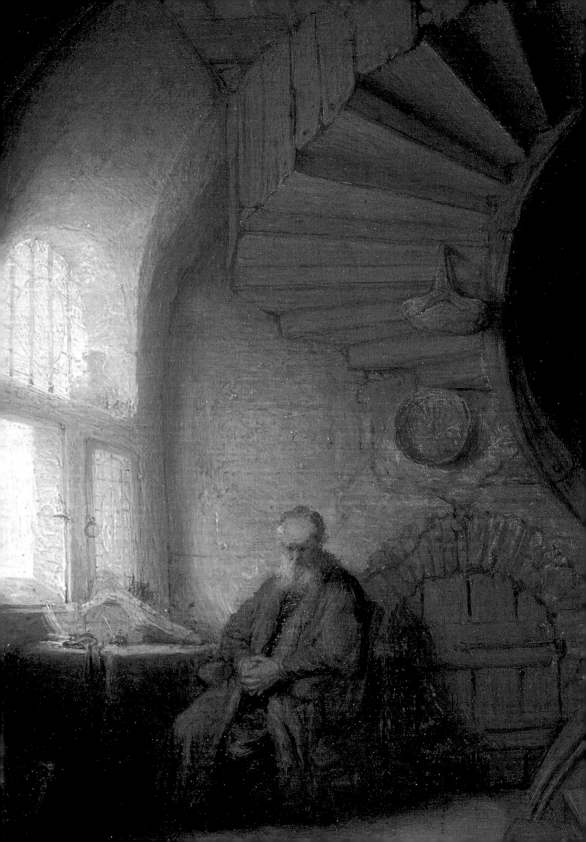

is a perfect path. Neither is superior to the other. We need them both, and we must keep both alive and in working order.

To put it more simply, we can say that the first path is that of philosophical thought, while the second (receiving the world without necessarily understanding it, or understanding it but without words, or beyond words) is that of mindfulness. It is the meditative approach of mindfulness that is the subject of this book.

Living in mindfulness

Mindfulness means intensifying our presence to the moment, stilling ourselves to absorb it, instead of escaping it or trying to alter it, through thought or action.

There is mindfulness in the action of the philosopher who turns for a moment from his work of thinking and enters a different mode of being, digesting and assimilating all that his intelligence has just produced or discovered, preparing himself, perhaps, to go further still, and pausing to be aware.

So mindfulness is not about creating emptiness, nor is it about producing thoughts. It means stopping to make contact with the ever-shifting experience that we are having at the time, and to observe the nature of our relationship to that experience, the nature of our presence at that moment.

This is what is happening now if, while continuing to read these words attentively, you realize that you are

also breathing and having bodily sensations, that there are other objects in your field of vision besides this book, that there are sounds around you, that there are thoughts calling you away or murmuring assessments and judgments of what you are reading, and so on.

Mindfulness means, just as you are about to turn this page and move on to the next (perhaps your hand is already poised, before you even finish reading these lines), halting your movement and observing, for example, the intention to turn the page that's already within you. Saying to yourself, "I'm going to turn the page," rather than doing it without even noticing. Mindfulness means making a tiny space every now and then to see ourselves doing something. You will tell me we don't need to do this in order to turn a page. And that is true. On the other hand, it may prove useful at many other times in our lives.

1.
BECOMING AWARE:
AN ATTITUDE OF MIND

Now the mind looks
neither forward nor backward.
The present alone is our happiness.

Goethe, *Faust II*

LIVE IN THE
PRESENT
MOMENT

t's now, right now. In a little while it will be something else—the magpie will have flown away, the sun will be higher in the sky, the shadow of the hedge will have retreated. It won't be better, or not as good, it will just be different. So now is the time to stop walking, feel the cold air sting our nostrils, listen to all the muffled sounds and admire the extraordinary light of sun on snow. We must stay here as long as we can, not waiting for anything in particular—quite the opposite! Just stay here, doing our best to perceive the countless riches of this moment: the clumps of snow that fall from the trees with a tiny, soft thud; the blue-white shadow of the hedge; the small movements of a magpie seeking a little warmth in the sun. Everything is perfect. Nothing more is needed for this moment to feel complete.

With mindfulness we can simply be present to this ordinary moment of light and grace.

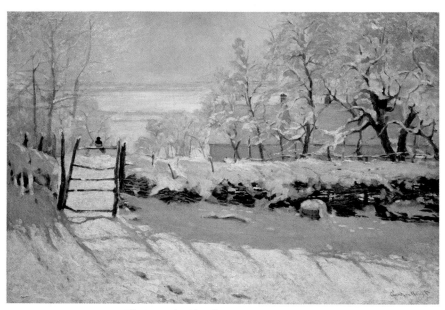

The Magpie, Claude Monet *(1840–1926)*
1868–1869, oil on canvas, 89 x 130 cm, Musée d'Orsay, Paris

To make a perfect winter day like this, you must have
a clear, sparkling air, with a sheen from the snow,
sufficient cold, little or no wind; and the warmth must
come directly from the sun. It must not be a thawing
warmth. The tension of nature must not be relaxed.

HENRY DAVID THOREAU, *JOURNAL* (FEBRUARY 1854)

Decide to inhabit the present moment

Mindfulness teaches us to open our eyes. It is important to do this because, here and now, there are worlds around us that we constantly ignore. We can enter them by interrupting the automatic flow of our actions and thoughts.

It's true that access to these worlds of the present moment is made easier by external gifts, such as the sun, snow and magpie of Monet's painting. But it also requires a decision on our part to open ourselves up as often as we can to being touched, contacted and struck by life. This is an act of deliberate awareness. We must decide to open our mind's door to all that lies beyond it, rather than hiding away in one of our inner fortresses, such as rumination, reflection, certainty or expectation.

Mindfulness is also liberating. It frees us from thoughts of the future or past, because it pulls us back into the present. And it liberates us from our value judgments, because it pulls us back into presence. Our minds are cluttered with so many things! Some are important, some are interesting, and some are completely pointless and futile. These pointless things hinder our vision and connection with the world. We need the past and the future, our memories and projects, but we also need the present. Both past and future matter. The philosophy of the present moment doesn't see it as *better* than the past or future, just more fragile. It is the present that we must protect, because it vanishes from our awareness whenever we

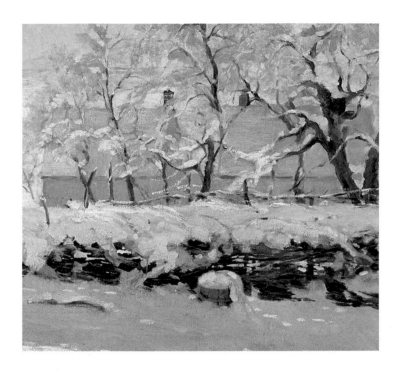

are rushed or busy. We must give the present the space in which to exist.

Feel instead of thinking: Immersive awareness

Mindfulness meditation isn't about *analyzing* the present moment, or at least not in the way people sometimes imagine. It's about feeling it, sensing it, with our whole body, without words. It is neither usual nor comfortable for us to do without language over a sustained period as we go through certain moments of our lives. Nor is it easy. Not talking is one thing, but not *thinking*! Just feeling and connecting. And

yet all of us have already had this experience. What happens at such times goes beyond words and is very precisely described in the following extract from *The Letter of Lord Chandos*, a magnificent short story by Austrian writer Hugo von Hofmannsthal: "Since then I have led an existence which I fear you could hardly imagine, so inanely, so unconsciously has it been proceeding. . . . It will not be easy for me to convey the substance of these good moments to you; words fail me once again at such times, filling any mundane object around me with a swelling tide of higher life as if it were a vessel, in fact it has no name and is no doubt hardly nameable. I cannot expect you to understand me without an illustration, and I must ask you to forgive the silliness of my examples. A watering can, a harrow left in a field, a dog in the sun, a shabby churchyard, a cripple, a small farmhouse—any of these can become the vessel of my revelation. Any of these things and the thousand similar ones past which the eye ordinarily glides with natural indifference can at any moment . . . suddenly take on for me a sublime and moving aura which words seem too weak to describe."

As a Buddhist master once said, "Mindfulness does not react to what it sees. It simply sees, and understands without words." Words can be immensely helpful to us at certain moments. Naming pain or joy can make us more able to bear, overcome, understand or savor it. But sometimes words can do nothing to help us express the complexity of what we feel, and

can even hinder, falsify or spoil our experience. There are times when it's better to say nothing. We must then be ready to relate to reality in a different way, sensing and feeling it. The term *immersive awareness* is sometimes used to describe this very particular state of mind, when we are intensely absorbed but not deliberately thinking, when we are just *in* the experience.

The intensity of experience

Once, on a mindfulness retreat, I remember our instructor asked us to do one of those odd exercises that are a specialty of meditation teachers. He got us to stand in a circle, then he asked us all to take a step forward. After a few seconds of silence he said, "Now try not to have taken that step." I had never heard—or more importantly experienced—anything that struck me more powerfully with the pointlessness of certain regrets. Above all, I had never so clearly understood the difference between teaching by speaking and teaching by experience. My surprise and confusion, the hesitation and agitation of my mind and the puzzlement of my body conveyed all there was to know about the impossibility of undoing and the pointlessness of regret. . . .

Mindfulness teaches us that experience is as important as knowledge. Reading about mindfulness is not the same as practicing it. Listening to a CD of meditation exercises to *become aware* of the content is not the same as *doing* the exercises.

Experience does not replace knowledge, reason and intelligence as means of access to reality, it is the piece that completes the puzzle. There is nothing simpler than experience, it just needs time. We need to stop and feel. And in order to look, listen and feel, we must stop acting, stop moving. Do it yourself. Now. Stop reading. Stop reading, close your eyes and become aware. Note what your experience is made of, right here and now. For a minute, right now. There is no one else who can do this for you. And no one else can meditate for you. Close your eyes.

LESSON 1

Living means living in the present moment. We can't live in the past or future; they are times we can only think and speculate about, churning over our regrets, hopes and fears. While we're doing that, we don't exist. Being regularly present to the riches in the moments that make up our lives means living more. Of course we all know this—we have read it and heard it said, we've even thought it. But all that is just talk. Now is the time to do it, for real! There is no substitute for experiencing the present moment.

BREATHE

Nothing is happening. There's no story, no message, just a paper carp alone at the top of its pole. We feel the cool of dusk that it feels. We hear the city sounds that it hears. We are looking down over Kyoto, magnificent and mysterious, in the company of a stone lion that seems to be watching the movement of people returning home, and another carp attached to another pole, a little farther back.

Nothing is happening. We hear only the flap of the paper bodies of the fish in the wind. On our skin we feel the movement of the evening breeze that swells the carp as it blows through them, bringing them fleetingly to life. Tomorrow, perhaps, it will abandon or tear them. But for now they are here, high in the sky, valiantly fluttering.

Nothing is happening. Wind. Emptiness. But this passing emptiness makes our mind breathe a little better. The wind is present in the painting, but invisible.

Like our breath, invisibly present in our body.

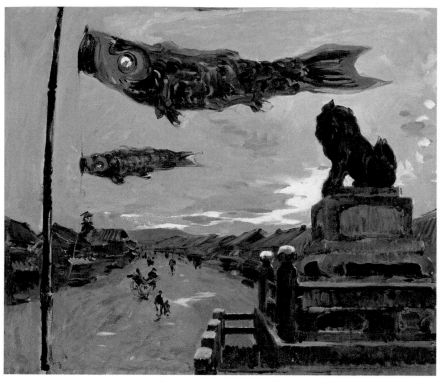

Carp Banners in Kyoto, Louis Dumoulin (1860–1924)
1888, oil on canvas, 46 x 53 cm, Museum of Fine Arts, Boston, Fanny P. Mason Fund in Memory of Alice Thevin

The wind blows where it will and you hear
the sound of it, but you do not know whence
it comes and whither it goes.

THE GOSPEL OF ST. JOHN, 3:8

Breathing, the core of meditation

Breathing has always occupied a central place in meditation practices. It is the most powerful means to connect to the present moment (or to realize that we find it hard to connect . . .). This is why one of the simplest and most effective pieces of advice beginners receive is to take the time to breathe, just breathe, for two or three whole minutes several times a day.

There are several reasons for the importance given to breath. Since the focus of meditation practice must not put the attention to sleep, it is useful to concentrate on a "moving target." If we are to avoid overtiring our attention, it is easier to fix it on something that is always present but never still. This is why we can remain fascinated and awake for long periods looking at the waves of the sea, the flames of the fire or the passing clouds—they are always there, but never the same. No breath is just like the one before or after. And of course there's the symbolic aspect—breath is life.

Breath is also important because we can exert a limited but real control over it by speeding it up or slowing it down. The same cannot be said of many of our body's other automatic functions. It's hard to alter our heart rate or blood pressure, or to speed up or slow our digestion. Work on breath is useful because it has an impact on our emotions.

We can use breathing to calm ourselves down. Not by controlling it, but by humbly connecting to it and gently observing it. The experience of accepting

a painful emotion by simply breathing as we register the feeling is a great introduction to the dialectics of will and letting go, about which we shall have more to say later. When things are not going well for us, when we are suffering from depression or anxiety, we do not breathe well. Working on our breath at these times will not solve all our problems or take away all our pain, but it will always lighten them. Why deprive ourselves of that?

The lessons of breath

Christians are familiar with Jesus' words to the paralyzed man: "Take up thy bed and walk." I sometimes like to imagine a worried man asking the advice of Buddha, who responds in symmetrical style: "Stop thy movement and breathe." We have so much to learn from breathing.

Breath teaches us about awareness. Our breath is invisible; we constantly forget it's there, but its role is vital—we have an absolute need to breathe. Similarly, there are many other things in our lives that we rely on but are unaware of.

Breath teaches us about dependence and fragility. Our need to breathe is even more clear and immediate than our other vital needs to eat, drink, love and be loved. Breath teaches us that we are dependent in many ways, and that these forms of dependence feed and develop us. The idea of reliance and dependence is sometimes disturbing to anxious people. "What if it were all taken away from me? What if I stopped

We can use breathing to calm ourselves down. Not by controlling it, but by humbly connecting to it and gently observing it.

breathing one day?" So they try to forget. The solution, of course, is not to repress the thought that our life depends on our breath, but rather to reach acceptance of this idea—which is an unavoidable reality—by contemplating it frequently and letting it wander through our mind unchecked. By making it familiar, we can defuse its charge of worry.

Breath teaches us about subtlety. It is simultaneously inside and outside us. It blurs the distinction between what is me and not-me. These distinctions are often illusions, and sometimes sources of suffering. It is not good to cling too closely to the certainty that we are on one side and the world on the other. This is why meditating in the warm summer breeze is an experience to savor. After a little while, the air inside us becomes one with the air in the world outside.

Breath teaches us about humility. Breathing is at once voluntary and involuntary, teaching us to accept that we cannot control everything. This is something that our society is keen to have us unlearn, trying to make us think that everything can be controlled and mastered. But breath also teaches us not to remain

passive and resigned. It shows us that we can still act, humbly yet effectively, with things that we do not completely control.

Breath teaches us about reality. Breathing is so important, yet breath has no identity of its own. It constantly forms and unforms. This is what Buddhists call *emptiness*—it's not that it doesn't exist, but it is not a solid reality in the way that we think, to which we can cling for safety as we would wish. Breath is like clouds, wind, waves and rainbows—very real, but fleeting, always there but always passing. . . .

Breath is always here

Breath is always here with us. It's a resource that is always available to us in becoming aware and connecting to the present moment by observing the movements of our breathing throughout our whole body, without trying to change them.

Breath is the anchor of mindfulness, helping us attach ourselves to the present moment. Sometimes it's what sailors call a floating anchor, the kind that allows a ship to slow down and not to capsize in the storm, when other maneuvers are no longer possible. Breath is like a friend who is always there for us. We must not ask it to give us the impossible. There's no point trying to breathe in order not to feel stress, anxiety, fear, sadness or anger. But breathing will stop us being engulfed. We focus on respiration in the way that we ask a friend to be with us when we have to face some problem or ordeal.

Are you in pain? Breathe. Are you in distress?
Breathe. At first, this message seemed very limited
to me. And then I understood. The real, full message
is, "Start by breathing. Then everything will become
clearer." The thing to do or think will then become
more obvious. Breathing does not change reality, but
it does change how we experience it, and preserves our
ability to act on it.

Once we have adopted the habit of regular
practice, it's no longer we who are breathing and
observing our breathing. Our whole body breathes, we
are *in* our breathing—indeed we are our breathing.
This is not an illusion or autosuggestion, it's
simply that awareness has led us to the core of one

of the thousand phenomena that make us living beings.

Breathing then becomes much more than respiration. It becomes a special path of communication and exchange with all that is inside us and around us, the painful and wonderful alike. For we can, of course, also breathe when faced with beauty and loveliness. . . .

LESSON 2

We often think that there's nothing very interesting about a phenomenon as familiar, ordinary and automatic as breathing. But we are so wrong! There are enormous advantages to becoming aware of our breathing—simply being aware of its presence and all the bodily sensations it connects to, without trying to change it. Just paying attention to it, when we are happy or unhappy, without expecting anything from it, without asking it to solve our problems. But understanding that, when we can't solve them, it's a thousand times better to pay attention to our breathing than to the ruminations in our minds.

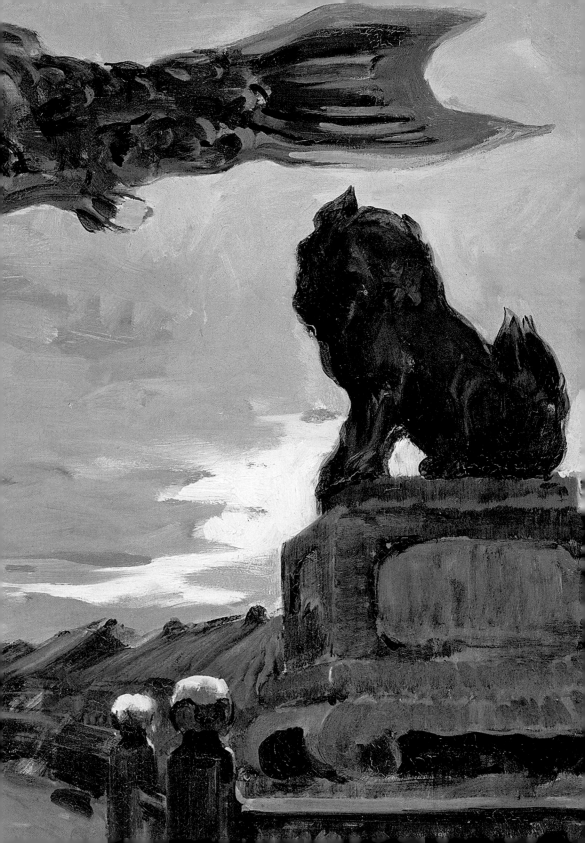

INHABIT
YOUR BODY

H e looks silly standing there in trousers that are too short, sleeves that are too long and shoes with red ribbons that were already outdated in his time. The white mass of his suit of moiré silk draws our eye—Pierrot is hard to ignore. But although he's in the foreground, no one else in the picture is paying him any attention. The other three figures in the background seem more interested in the arrival of a fourth, riding a sad-eyed donkey.

Pierrot looks sad and calm. He's no doubt wondering whether people look at him because they like him or to laugh at him. But he doesn't really care. He's resigned— used to not being admired, to being forgotten. But he goes on standing there, because he's also used to people

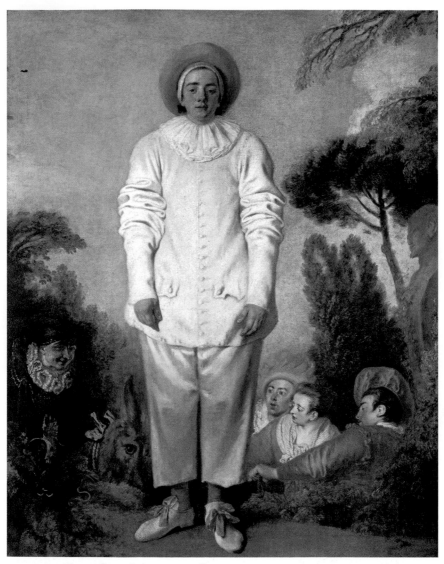

Pierrot, formerly known as Gilles, Jean-Antoine Watteau (1684–1721)
c. 1718–1719, oil on canvas, 185 x 150 cm, Musée du Louvre, Paris

eventually realizing that he's necessary. The story can't go on without him.

He's not really handsome, but there's something about him all the same, a simple, obvious presence. Pierrot reminds us—and we need reminding—that our body doesn't have to be beautiful, strong or supple for us to love it and understand how important it is in our lives, acting as our guide in the world of mindfulness. . . .

Is there a mind/body problem?
If so, which is it better to have?

Woody Allen

Meditate with your body

Non-meditators often think that meditation is a purely mental practice. How wrong they are! In reality it's an eminently bodily practice. After long meditation sessions the body can sometimes feel even more drained than the mind.

Mindfulness is a form of meditation that particularly draws on the respectful experience of bodily sensations. It involves connecting with our body, being aware of it and attentive to it. This does not mean *thinking* about our body and judging what is happening inside it, trying to relax it or getting annoyed with it. It simply means making contact with it and reintegrating it into the mental world of our attention and awareness. Without trying—at least at first—to change anything at all.

All approaches to mindfulness involve many regular exercises based on the body. These may include taking the time to simply notice our body, gently, one part at a time; making it the gravitational center of our experience of the present moment; practicing exercises on posture, for example, taking ten breaths every morning while standing as straight as we can without stiffness; being aware of our posture and correcting it gently and naturally, to give it dignity and comfort, and taking the time to feel what this does to our body; doing slow stretches in mindfulness—the variations are endless.

This is not a matter of gymnastics; it is a path to self-knowledge that does not involve words. It is perhaps

more crude, but also more primal than psychic introspection. It is a kind of bodily introspection, calm and benevolent, which involves gently saying to ourselves, "Let's take a little time to see and feel how we are inside." Often, this can help us. When we are lost inside our own head, when we are confused, our body doesn't lie, it tells us. So the body is not to be scorned, as Nietzsche reminds us. He said, "I want to speak of the despisers of the body. I would not have them learn and teach differently, but merely say farewell to their own bodies—and thus become silent." Sometimes the problem is one of forgetting rather than scorn. We forget about our body and imagine we are pure mind. We treat our body as a tool, expecting it to give us silence (health), pleasure (of our organs and senses) and obedience (transporting and serving us). By providing us with all this it is already giving us plenty. But it has much more to offer us. . . .

The body: gateway to the mind

Body and mind are totally inseparable; neither ever lets go of the other. Calmness in one affects the other, and so does excitement. There is much talk of the legend of Cartesian dualism, in which the body and mind are seen as two separate entities, but Descartes never said such a thing. In fact no one has ever said such a thing. This duality is simply a description of a hierarchy, a belief about power relations—which imposes obedience on the other? In general we believe that the mind should be stronger than the

body. But, as in any couple, this changes from one moment to the next, one context to the next. The relationship changes and develops. And that's just how it should be.

Body and mind are neither one and the same nor two separate things. They are two different but very closely connected realities. Being aware of the connections between them can teach us a great deal. This is what it means to experience your body. It doesn't mean thinking quickly and vaguely, "Yes, yes, I've got a body and it's important to take care of it." It means stopping as often as possible to feel what is happening inside us at that very moment and connecting to it. Deliberately, subtly and respectfully feeling and sensing it. And not only when our body gives us pain or pleasure.

We need to learn to understand our sensations and to pay attention to them. They are our dashboard, reflecting the balance or imbalances within us. Sometimes, when we allow our body to exist for our mind, we feel strange sensations, as though we were leaving our body behind and it was floating, or very heavy, or changing shape. Sometimes too we sense the arrival of something unpleasant and we become aware of tensions or pain that we had been avoiding through distraction, being busy or ruminating on external matters. Meditation differs from relaxation in that its aim is not just—or not primarily—to do us good or make us relax, but simply to be aware of what is happening inside us. And sometimes what is happening is painful. But mindfulness recommends

that we accept and observe it, acknowledging the pain rather than fleeing it.

Benefits and repair

It has long been known that when we do our body good it does our mind good as well. Alongside physical activity and relaxation, smiling and a straight, dignified posture have effects on our state of mind. These effects are discreet and cumulative. They are also unpredictable. This is why, in mindfulness, it is recommended not to "try"—not to try to relax, do ourselves good, or attain any particular state. At any rate, not during meditation. Meditation is not a time to hope or aim for anything, but simply to open up to what exists, to be present, to receive it into our awareness. No more than that. The keywords are *enable* and *facilitate*.

Facilitate, because for a few years now researchers have had the feeling that the body has the ability to repair itself (we should be clear that this is not a guarantee of health or immortality), which can be facilitated by offering it gentle pleasures and happiness, and also simply by giving it some mental space, listening to it and allowing it to express itself. Meditation seems to slow cellular aging, by acting on the little hoods at the end of our chromosomes, known as telomeres.

Giving ourselves the space to experience our bodily sensations on a regular basis is undoubtedly beneficial to our health. This is why mindfulness practice recommends an exercise that involves regularly reviewing

each part of our body, calmly and gently. We go along all our body's paths, just as we might walk along the paths of a forest, picking up any fallen branches and checking that all is well. Even if our body is sick, in pain, damaged or worn, we give it attention, esteem, space and affection, to the best of our ability, here and now.

We do so in the quiet, distant expectation that this body, as it is, will be calmed by being accepted, and that a calmed body will enable an enlightened mind. . . .

LESSON 3

It's odd how most of us tend either to forget our body or to worry about it, swinging between denial when we are well and hypochondria when we are sick. Mindfulness recommends that we simply pay it regular friendly visits, reconnecting to our sensations, observing how things are and reviewing them calmly as we go to sleep, on waking and whenever we have a free moment. We should check what's going on in our body—not trying to solve or soothe anything, just observing. This in itself will have the great benefit of making a little space for our body within our awareness.

CLOSE
YOUR EYES
AND LISTEN

Painting is not just for the eyes. Some pictures also whisper in our ears. This one, for example, is a painting to listen to—and to look at, of course, but above all to listen to.

We hear the cries of the children playing and their mothers telling them to calm down. There's the gentle rustling of the wind in the leaves, birdsong, and perhaps a dog or two barking in the distance.

Then suddenly, amid all this, we hear a strange and growing noise: *ch-ch-ch, tidum-tidum-tidum* . . . The sound of the steam locomotive gets louder and louder, making its presence felt, filling the space with its panting breath and the rumble of wheel on rail. *Toot-toot!* There goes the whistle that the driver blows, from joy or habit, as the train crosses the viaduct.

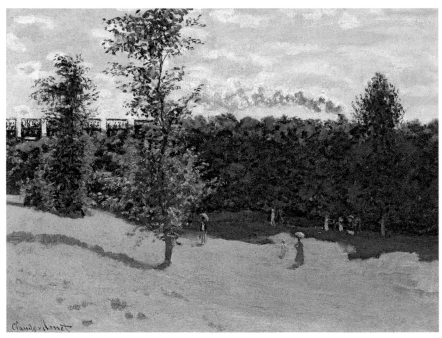

Train in the countryside, Claude Monet (1840–1926)
c. 1870, oil on canvas, 50 x 65.3 cm, Musée d'Orsay, Paris

And then it all fades away again. The train vanishes, we can only just hear it in the distance. A moment longer and there's nothing left at all, the sound has imperceptibly dwindled and dissolved. We are left with nothing but the memory of its passing. When did the sound of the train disappear exactly? How long did the whole thing take? How long was our mind held in thrall? Some might say these are meaningless questions and perhaps in some ways they are. But perhaps too they are very meaningful because they have much to tell us about the way that our mind listens to life—or not.

Life goes on, moment by moment, and gently the sounds of the children, mothers, wind and birds return to the forefront of our awareness. And maybe a dog or two, still barking in the distance.

To a bird's song I listen,
Not for the voice,
but for the silence following after the song.

YONE NOGUCHI

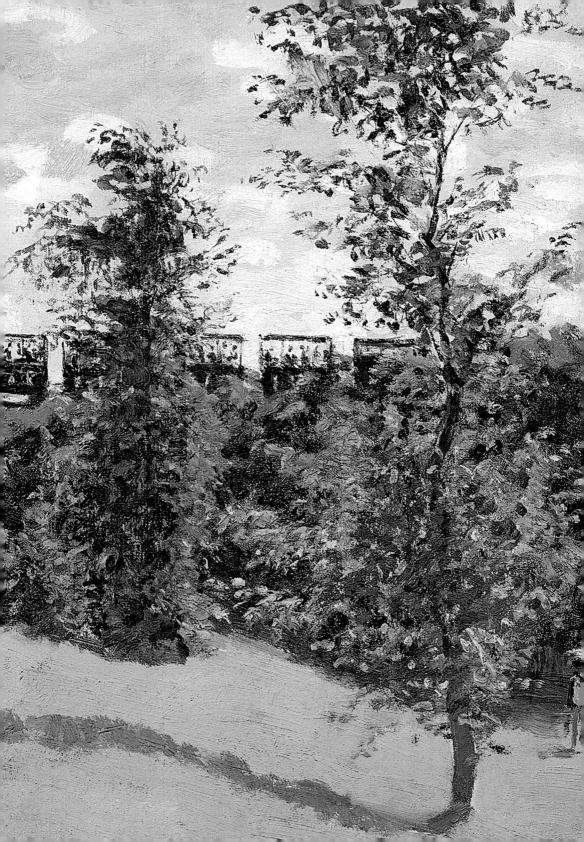

Sounds of all kinds

What are the differences between noises, sounds and music? A noise is anything that touches our ear—any auditory sensation. A sound is a noise that has meaning (the sound of a voice or a bell); it is an organized, identified noise, analyzed by our mind. Music is a set of complex, superimposed, harmonious sounds.

We are surrounded by a constant world of sound, which we notice only now and then. Sound recordists for film or radio know how to re-create different ambiances, both human (open-air market, café or office) and natural (the seaside, a forest in autumn, and so on). When we listen to them attentively we realize all the complexity, and sometimes beauty, of these sound worlds.

We need these sounds, particularly the real sounds of life and nature. They are organic nourishment for our ears, brought to us by the sea, mountains and countryside. They are the ancient sounds of our animal roots, which is why they have such a calming effect on us.

Hear, listen, think . . .

When we hear, we adopt an attitude that is receptive, "passive," or rather, non-interventionist. When we listen, our attention is aroused and deliberately directed to noises, sounds and our analysis of them.

Now our thoughts are engaged. We *hear* the sound of an ambulance and at once we *listen* to it, giving it

a meaning, sometimes unconsciously. We may *think*, for example, that there has been an accident, or that someone is very sick, and we may feel compassion, concern or sadness.

We *hear* footsteps in the flat upstairs. We *listen* a little more closely and try to recognize the sound of the movement. We may visualize a particular person (a woman if it is the sound of high heels, or someone we know who tends to walk that way). Sometimes we make a value judgment: we like or dislike the sound, we start thinking about all that it means. This production of thoughts based on noises and sound at once enriches and impoverishes us. The meaning that we give to sounds competes with our presence to the world.

As soon as we produce words, we tend to leave the experience of our senses behind. We are no longer in the world of sound; we have left it for our mental world. This doesn't really matter, and sometimes it's necessary, even vital. Sensing isn't always enough; we must also understand. But, as with all our mind's automatic reflexes, it is important to realize what's happening inside us. It is important too to make a regular effort to free ourselves of these reflexes, and to return to listening to life neutrally and receptively. Listening with mindfulness, which sometimes gives us access to something unheard-of. Something we have never heard, because we were never really listening. . . .

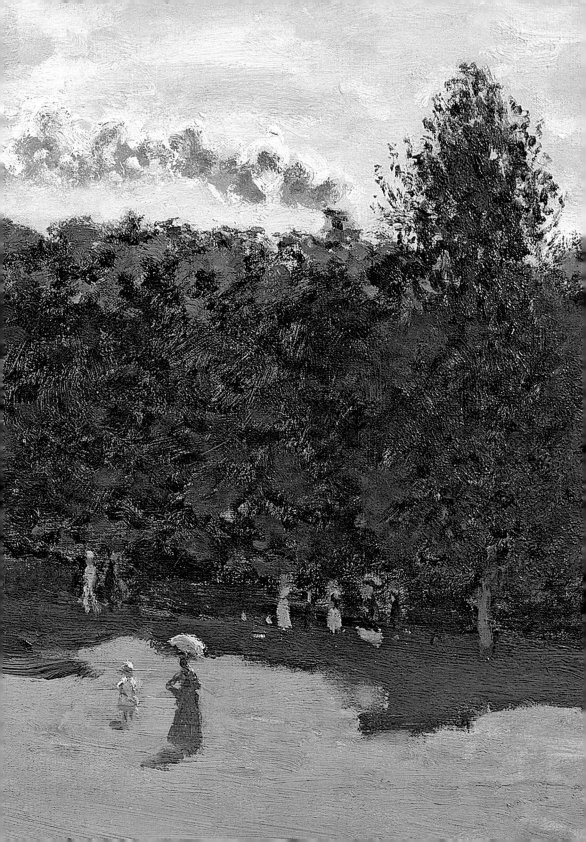

Notice sounds with serenity

When we work on sound, with mindfulness, we strive to notice everything, to fight the constant temptation to filter ("That's a distracting noise, I'll try not to think about it") and to judge ("What a horrible noise those people are making revving their engine"). Mindfulness is not relaxation (where we need silence, or quiet at least), but meditation (where we are trying to cultivate a calm relationship with the world). We can practice with noises all around us. Even if we would prefer things to be different, we must be able to do it.

In mindfulness we often practice simply paying attention to sound, to the basic properties of sounds—are they near or far, high or low, continuous or intermittent, are there moments of silence, pauses? We strive to observe and notice their primary characteristics, to take them as they are.

Of course our mind will naturally seek to interpret sounds ("That's the sound of this or that"), to judge them ("That's nice or nasty") and to link one thought to another ("That reminds me of . . . ," "that reminds me that"). This is normal. There's no point getting irritated, because this is what the mind always does, judging and surrounding our experiences and sensations with chatter. It doesn't matter, as long as we are aware of it. Working on sound means observing in ourselves the difference between sounds and their meanings. And then going back to simply listening, taking sound as sound. If our thoughts keep coming back, that's normal, it's as it should be. It teaches us

to understand the workings of our mind. And if our thoughts leave us in peace, that's as it should be too. It teaches us to savor the taste of sound.

Often, when we practice in a group at the hospital, a patient's mobile phone will ring. Without stopping the session, I tell them, "This is a wonderful opportunity. Let's stay with the exercise and keep our eyes closed. Let's notice the sound and perceive the thoughts it produces in us— 'That's annoying'; 'The phone's owner must be embarrassed'; 'How rude!'; 'Is my phone off?' Let's observe and smile at all the things this phone sound produces in us." In the same way, when one of the participants comes into the session late while we are doing an exercise, we keep our eyes closed, listen to the person get settled and amuse ourselves noting the sounds they make and the thoughts that are triggered within us. This position of calm observer is the very core of mindfulness practice.

Silence

Silence is to noise what shadow is to light or sleep to being awake—the indispensable other side. Being permanently surrounded by sound is toxic. It adds to the accumulation of excitement imposed on us by so-called "modern" life. Even when it is interesting (continuous news on the radio) or harmonious (music everywhere), its constant presence tires and weakens us, preventing our mind from breathing, and then from functioning, like a kind of constant chatter that takes the place of our thoughts.

So we need to remember the power of silence as a sounding box for the noises of life. Not necessarily complete silence, but its presence between sounds and between moments when noise is inevitable (a journey through town) or desirable (conversation and music at a party). Moments of silence are like breaths or parentheses. They enhance the sounds we love and provide relief from those we find harder to bear.

This is the power of silence and its cousin, quiet, which is not the absence of noise, but of pointless talk and artificial interruptions. Silence and quiet enable us to hear and listen to all the strands of the music of life.

LESSON 4

Stop, close your eyes and listen. Notice all the sounds. Outside us some are pleasant (a bird singing), some unpleasant (an engine roaring); inside us some are calming (our breathing), some disturbing (tinnitus and gurgling). The point of these moments of auditory mindfulness is not to do us good—at least not directly—but to open our eyes, if I can use such a phrase here, making us aware of the existence of all these ambient sounds and the emotions, thoughts and impulses that they trigger in us. And then, of course, to savor the silences.

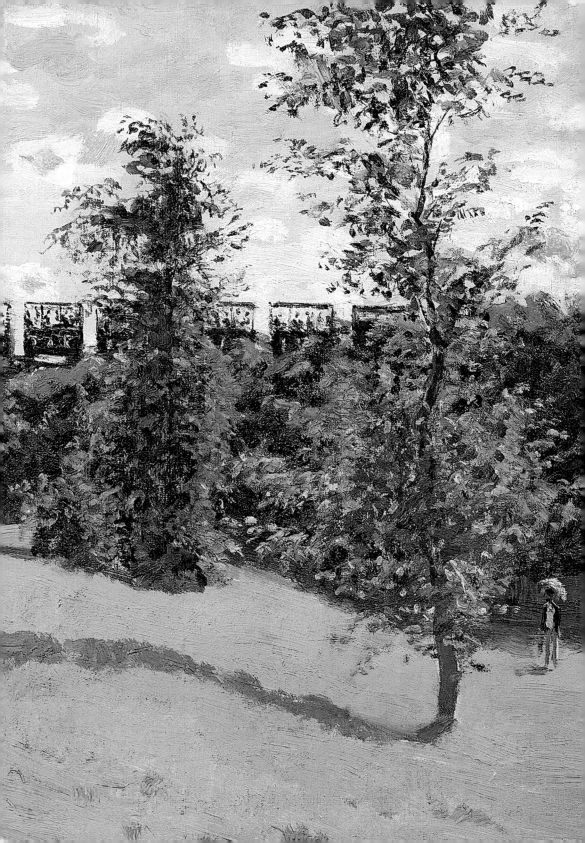

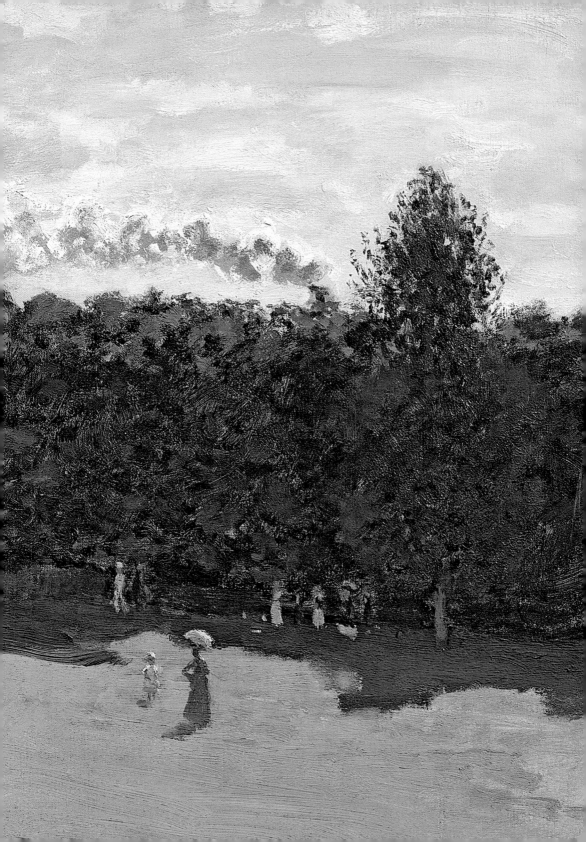

OBSERVE YOUR
THOUGHTS

The man out walking has stopped. In doing so he has silenced the rustle of dead leaves crushed by his feet, a soothing sound that accompanied him as he walked. He has stopped by this large puddle. He thinks that there's been a lot of rain in the last few days; the earth can no longer soak up all the water that's fallen from the sky, so it is keeping it waiting on the surface, in the way that a restaurant manager keeps clients waiting when he has no free tables.

The walker has stopped and he's thinking . . . no, it's not him who's thinking. His mind is chattering to itself. He listens and notices this chatter: "Beautiful colors"; "Some are rotting already"; "Will I ruin my shoes if I walk in the water?"; "I used to do it when I was little, but back then I

Reflection (What does your soul look like ?), Peter Doig *(born 1959)*
1996, 280 x 200 cm (PD 82)

was wearing Wellington boots"; "What's the time?"; "One day I'll be dead like those leaves"; "It's a good thing I'm wearing my coat, it's cold, winter has come early this year."...

Then gradually, his jostling thoughts fall silent. He feels his own breathing and notices his heart. His attention is held by one leaf that is half rotten. He simply sees it. He also sees all the others. He has no desire to move, just to stand there. From time to time a new thought crosses his mind. He hears it, in the way that he sees the leaves. Presence and distance. One thought whispers, "Your thoughts are like these leaves, there are a lot of them, in every way, let them come and go, that's fine. This moment is perfect. You need expect nothing more than what you are experiencing here and now."

Then his thoughts fall silent. A glimpse of eternity.

There are, we saw, two processes which human beings cannot bring to a halt so long as they are alive: breathing and thinking. In fact, we are capable of holding our breath for longer periods than we are able to abstain from thought (if that is possible at all). On reflection, this incapacity to arrest thought, to take a break from thinking, is a terrifying constraint.

GEORGE STEINER, *TEN (POSSIBLE) REASONS FOR THE SADNESS OF THOUGHT*

Chattering minds

Our brain is an amazing machine for producing thoughts. Amazing, but very hard to stop. As soon as we wake up, the production of thought begins. In his treatise *On Tranquillity of Mind*, Seneca writes of "that tossing to and fro of a mind which can nowhere find rest." To wake up in the morning is to start to think, or rather to be assailed by a torrent of thoughts, talking to us about everything, past, future and, less frequently, present.

In reality, what we call thinking or reflecting is not *producing* thoughts (that work is beyond our will or intervention), but sorting and organizing them, putting them into a hierarchy, trying to focus on some and develop them, while trying to banish others. This is why it is pointless to hope that meditation will lead us quickly, and to order, to a kind of mental silence or absence of thoughts. This does sometimes happen, but only for a moment now and then. Then the chatter starts up again.

"Consciousness reigns but does not govern," said Paul Valéry. I have always liked those words, which seem to me to express the crucial thing, which is the difference between power and omnipotence. Within the Buddhist tradition Matthieu Ricard compares the torrent of our thoughts to a troupe of monkeys always moving, shrieking and jumping from branch to branch, never still. What a racket! And what scope for confusion! What can we do? It's a tumult that's impossible to stop and hard to control. Besides, there's

a risk that we might replace our scattered thoughts with concentration on just one, which is called obsession and isn't much better. Another risk is distraction—we fill our minds with something else, something easy, external, channeled and strong enough to capture our attention, and at once the chatter stops. Padding rather than chatter—why not? But there are other methods we can develop.

In mindfulness, we give up trying to stop or flee the torrent of our thoughts, choosing instead to observe it by, as it were, stepping aside—thinking, and watching ourselves think. Zen gives us the metaphor of the waterfall. We are between a waterfall (the torrent of our thoughts) and the rock behind it. We observe ourselves thinking from a step back. We are no longer inside the torrent (distance), but we are still close to it (presence). We are using our capacity for reflective awareness in the form of self-observation. But can we really observe ourselves thinking? First-person psychology has long been disregarded, in both its introspective and phenomenological forms—there's an obvious conflict of interests. "We cannot sit at the window to watch ourselves pass by in the street," said Auguste Comte. Yet, where awareness is concerned, this is possible. It just takes an awful lot of training. . . .

Watch your thoughts go by . . .

As always with mindfulness, we must abandon any head-on, brutal action. There's no point trying to suppress our thoughts; often that just makes them

bounce back all the more strongly. And it's also hard to think, "I'm going to observe my thoughts." Often it will seem to us that there aren't any. But this is because we are too close to them. We are so far *inside* our thoughts, we *are* our thoughts to such an extent that we take them for reality.

Mindfulness tells us only that it is pointless to try to block our thoughts, or to try to seek them out. It is much better to expand our mind.

So we start elsewhere, by attaching, anchoring and centering ourselves on the present moment by means of breathing, listening to sounds and perceiving our bodily sensations. Doing this we are already in a better position to observe the movement of our thoughts. While we are busy with other things, for example focusing on experiencing our breathing, after a while we notice that we have allowed ourselves to be carried away—we were in our breathing and all of a sudden we have started "thinking about something else"; we have followed a passing thought, without realizing. We realize only afterward.

With a bit of training we can identify thoughts by the orders that they give us when we try to distance ourselves from them. When we are doing a mindfulness exercise that involves trying simply to be there, present to the movements of our breath and the sounds around us, suddenly there comes an impulse, a desire, an order: "Stop, open your eyes, do this or that thing that's more urgent, more important." If we resist, our thoughts insist: "Do it *now*, or you'll forget!" We think that it is

In mindfulness it is we who choose whether to follow our thoughts— why not?—or do something else.

we who want this, that we *need* it, but we may well be wrong.

We can prove this by ignoring our reflex of instant obedience to these orders that are disguised as desires, impulses and necessities—orders such as "Scratch your nose"; "Open your eyes and look at the time"; "Remember to phone your brother." When we do not instantly obey them, we often realize that they are debatable and avoidable. We can disobey, or defer obedience, but only if we are aware that these intrusions are simply thoughts.

At the start we identify these thoughts when they have led our mind away from the exercise and we are no longer in our breathing or our body, but "thinking about something." This is normal, it's what our mind does all the time, so, without annoyance, we can return to the exercise. Thoughts return. We notice them and we return to the exercise, and so on. These movements are fundamental to training in mindfulness. Thoughts are not a problem, the problem is not being aware of the mental scattering, agitation and above all confusion (of thoughts with reality) and attachment

(taking *all* our thoughts seriously). The problem is not so much the content and movement of our thoughts as our relationship to them. So we should not try to block them, or drive them away. But nor should we follow them, obey them or resign ourselves to being ruled by them. We should notice and observe them in a context of expanded awareness (hence the importance of anchoring ourselves in the present moment using breath, our body and sound), and stop nourishing them.

Gradually, with training, we come to see our thoughts more clearly as just thoughts. We become more able to identify them as fleeting mental phenomena, rather than lasting certainties. We see them appear, and often, if we don't follow them, we see them evaporate. Then come back. Then go away again. *Experiencing* this has far more to teach us than just knowing it. We know that our thoughts are just thoughts but, when we are carried away by them, this knowledge is no use to us. Only regular practice and experience can help us distance ourselves from what is happening in our mind and develop the habit of allowing our thoughts to evaporate by themselves.

In mindfulness it is we who choose whether to follow our thoughts—why not?—or do something else. We can choose, for example, to sit here, eyes closed, breathing, here and now, amid the torrent of thoughts telling us to "move," "do," "think," and which start to get annoyed and more insistent—"You've got so many urgent things to do, don't you think you should stop doing this exercise? You can do it later."

But we have decided not to obey these thoughts. We wait a little, just to see if we really must go off in those directions, if those things really are that important. We go on breathing for a few minutes more, and the vise loosens. How good it feels to stop being a slave to the workings of our mind! How happy we are to regain a bit of freedom!

Free yourself from your thoughts

"I think, therefore I am," said Descartes. Paul Valéry added, "Sometimes I think, and sometimes I am." And mindfulness concludes, "I am not only what I think." Cognitive psychotherapy uses the term *defusion* for this effort to reduce the confusion of our thoughts with our awareness. We need to understand that our thoughts are only one element of our awareness and not all of it. We can stop being dependent on our thoughts without rejecting them, but simply adopting a different relationship to them.

Saying to myself, "My life is sad" and "I'm thinking that my life is sad" are two very different things. By identifying my thoughts as mental phenomena I can more clearly see that they contain a great many value judgments, reflexes and impulses that I don't necessarily have to accept. This rather strange experience of disassociating ourselves from our own mind, striving to use our mind in order to avoid being trapped by it, is what mindfulness offers. It teaches me to open up a space for reflection and to cultivate my experience of distance and observation. It helps me untangle

background noise from an interesting conversation, as I would at a party, or choose instead to step outside, leaving the shouts and music behind, to listen to the murmur of the night. . . .

LESSON 5

Close your eyes and focus your attention on your breath. Then observe how very quickly your mind slips away, or rather how your thoughts take over the center of your attention, like capricious children. Thoughts about things to do, or how hard it is to stay in the exercise. You are still in it. Mindfulness work on thoughts simply means being aware of the irrepressible chatter of the mind and its power to draw us in. A moment comes when we are no longer observing our thoughts, but in them, carried away. We must then return calmly to our breathing, and then to observing our thoughts. Gradually the difference between "thinking something" and "noticing that we are thinking something" becomes clear. This is what is called lucidity, and it requires regular work.

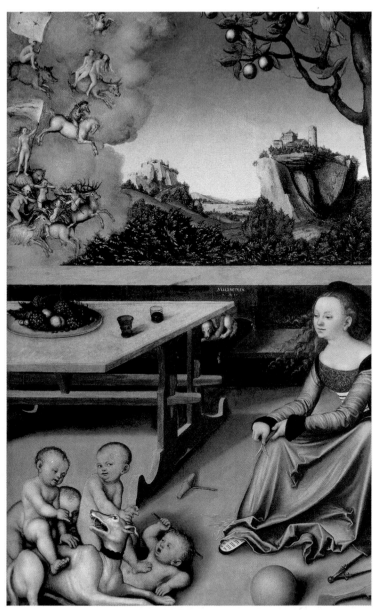

Melancholy, Lucas Cranach the Elder (1472–1553)
1528, oil on wood, 113 x 172 cm, private collection

MAKE SPACE
FOR YOUR
EMOTIONS

I t's a combination of order and chaos—surprising, indecipherable and, in a quiet way, disquieting. It's not easy to tell what the painter is trying to tell us. Then, after a while, although we don't understand any better, we do start to see how the painting is organized.

On the left-hand side all is in turmoil. There's supernatural turmoil above, with a cloud-borne cavalcade of spirits or phantoms, and everyday turmoil below, where naked children and a greyhound are sprawling and brawling, the mistreated dog turning on them with a threatening snarl, ears back, teeth bared, as if to say, "Stop that or I'll bite you!"

On the right-hand side things are much calmer, but no clearer. An apple tree bears golden fruit; a castle perches on a rocky escarpment; a woman sits whittling a thin stick, apparently to pass the time, tools scattered at her feet. Her expression is weary, distant, slightly scornful, and she seems to be keeping a distant eye on the brawling children and dog.

Cranach's *Melancholy* is a combination of reality and unreality, tension and calm, business and boredom. It contains things that we understand—more or less—and others that are beyond our grasp, and which we sense will always be so.

But isn't that also often true of our own emotional experience?

Everything rests on a few ideas
that are fearsome
and cannot be looked at directly.

PAUL VALÉRY, *TEL QUEL*

Emotional experience

Our emotions don't speak, but they do express themselves—in bodily sensations, behaviors and extreme, simplified, reflex thoughts.

By the same token, to calm and soothe our emotions, words are not usually enough. We have to approach them through our body (breathing) and behavior (walking if we are sad or worried, lying down if we are angry). It is one of the hardest processes of mental life to distance ourselves from thoughts saturated with emotion, which we struggle to prevent or dismiss. The current view is that it is

easier to establish this necessary distance by noticing and observing our emotional states than by struggling to suppress them. Obviously we can't do it by obeying them. Experiencing our emotional oscillations is a test of our humility and realism. To start with at least, our emotions are often more powerful than we are. We can see this clearly with strong emotions and indirectly in the moods that are their subtler forms. As La Rochefoucauld observed, "The humours follow a course that imperceptibly diverts our will; they roll along together and successively exert secret control over us, playing a considerable part in all our actions, without our being able to tell."

Emotional chaos

The experience of what we are feeling emotionally is not always pleasant, nor is it always intelligible. True, the chaos of our emotions can sometimes be fertile ground, but it can also generate the greatest confusion.

So we may be tempted to escape into action or distraction. There is also the temptation of hypercontrol, refusing the right of painful emotions to exist, forbidding ourselves to feel them. This is logical, but problematic. By acting in this way, trying to cut ourselves off from our sensations and feelings, we are exposing ourselves to what neurologists call "deafferentation," and so to the amputation of our emotional intelligence. I have often seen hypersensitive patients who have managed for years to freeze the flow

of their emotions, which they find too painful. It makes me think of permafrost, the layer of earth lying under the ice, which is always frozen and in which obviously nothing can grow. Their lives and sensibilities have been impoverished by overprotection. . . .

Emotional clarity—be willing to feel

Mindfulness runs counter to our natural tendency to retain what is pleasant and reject what is unpleasant. This is why sessions and exercises are not always comfortable (another difference from relaxation).

In mindfulness we notice negative and painful feelings and simply allow them to be there. So rather than trying to drive away unhappiness and dissipate worry, we start by accepting their presence. This does not mean that we accept their messages and commands. Allowing sadness or worry to be there means observing that we are sad, but not necessarily believing all we are told by sadness ("Life isn't worth living—what's the point of doing anything?") and worry ("There's a danger—you've got to act quickly and find a solution").

Patients who are anxious or depressed don't like being told to start by allowing their feelings to be there. They find the idea rather shocking—"I've always tried to do the opposite, not to feel pain." And they find it frightening—"If I open the floodgates, if I let my guard down, I'll be overwhelmed by pain."

But don't worry, this is not what will happen. Our negative emotions are like animals (or people) that we want to calm down—the more we rush to drive them

In mindfulness we notice negative and painful feelings and simply allow them to be there.

away, tie them down or lock them up, the more they fight back and can hurt us.

So it's better for us to make space around them and allow them to exist. This also allows us to observe them. What state do they put my body in? What thoughts do they lead to? What do they make me do? This way, we are not inside the emotion, but experiencing it and noticing it, in order to be less dominated by it. Sometimes this is enough in itself to calm us and enable us to decide what to do.

Emotions are the driving force behind negative thoughts, giving them their force and solidity. By accepting my emotions I defuse their power over the thoughts they push along in front of them to hide their progress. I can think more easily about my angry thoughts if I have acknowledged and accepted my anger, and think more easily about my worries if I have acknowledged and accepted my anxiety. Whereas, if I go on thinking, "No, I'm not angry, it's what's happening that's unacceptable," or, "No, I'm not worried, it's reality that's threatening," this work on my thoughts won't happen, because, to my mind, they are not thoughts but obvious realities. Who would be so mad as to doubt an obvious reality?

Take time to feel

So we are going to have to work on our feelings. Not to prevent them, but to observe them. We can do this, for example, several times a day, between doing other things. Instead of rushing straight from one thing to the next in haste and stress, we can take time to feel what is happening inside us, gently connecting with our emotional state. Or, when we are waiting for something, we can use the time to become aware of ourselves, instead of passing through these moments unawares, mentally absent, cut off from ourselves, our minds elsewhere, focusing on actions or rumination.

The habit of calm, curious introspection begins in moments of calm and rest. Then, we can adopt it when we are suffering—when we are sad, irritated, worried or unhappy. We shouldn't seek to modify what we are feeling, or to console or calm ourselves. Not straight-away. We can just be present to what we are feeling and breathe properly, not "trying" for anything more than to focus our breathing and observe what is happening. Breathing, presence—mindfulness is a bit like a lantern in the darkness. We can see where we are, even though it's still night. And sometimes we get quite a surprise. By accepting our painful feelings, consenting to go through them, we discover that it's a bit like going through a cloud. Ultimately, there's nothing very solid there. And when we come out the other side, the sun is shining again.

Mindfulness and emotions

Our emotions, however unpleasant, are not "weeds" in our mind. They are part of our mental ecology. Accepting them is possible and viable only if we are aware of them and their powerful or subtle mechanisms of influence. Having feelings is natural for us. We need to act on their influence rather than their presence. And the goal of what psychologists call "emotional regulation" is not emptiness, calm or coolness—at least not straightaway, or not directly. The goals are awareness and clarity.

So mindfulness requires two fundamental skills that enable us to advance down the path of emotional balance. The first involves creating an inner space in which to experience the present moment; the second is noticing this experience as it is and allowing it to exist. To overcome suffering or discomfort, we must first have accepted that they exist within us. We can't leave a place unless we have admitted to ourselves that we have reached it, and we can't free ourselves from suffering that we have never allowed ourselves to acknowledge.

It is only by doing this that, in moments of emotional distress, we can listen to and believe our own words of comfort—it doesn't really matter, it will pass, that kind of thing. This only works if we have first fully accepted the problem. It won't work if we are still refusing to accept its existence ("That's impossible, it's not fair"). The seeds of serenity can only grow in the soil of lucidity, not in denial or self-deception. For

soothing words to have a soothing effect, we must take the time to notice, hear, sense and feel them. To make them live within us, as we have already done with the painful emotions. Because of course, there is no ban on making space for pleasant feelings too.

LESSON 6

When I'm troubled, upset or worried, I must not look elsewhere to free and soothe myself. On the contrary, if I have time, I should observe what's happening inside me. What is this emotion that inhabits me? Which way is it pushing me? This may seem very simple, but of course it isn't. Our emotions are as inescapable as our thoughts. In other words, they don't appear as subjective phenomena but as obvious facts—indisputable reality. So I shouldn't try either to change what I feel or to console or calm myself. I must just be present to it. I must breathe properly and not "try" to do anything other than to focus on my breathing and observe what's happening inside me.

USE YOUR
ATTENTION
TO EXPAND
YOUR AWARENESS

A t first it all looks simple. The painting is divided in two. It depicts a street magician on the right and, on the left, his audience. Between them is a table. Then we start noticing the details. We smile at the jolly conjurer with his funny hat. We see the little owl, symbol of trickery and duplicity, discreetly concealed in the basket he holds in his left hand while, in his right, he holds up a ball that has undoubtedly reappeared from under one of the upturned cups on the table. We note that the man bending over the table in fascination is very tall. And we realize that he is being relieved of his purse by a pickpocket staring strangely skyward, as though to distract attention from what he is doing. We wonder, is the robber in cahoots with the conjurer? And perhaps with the woman being pointed at, who is also dressed in red?

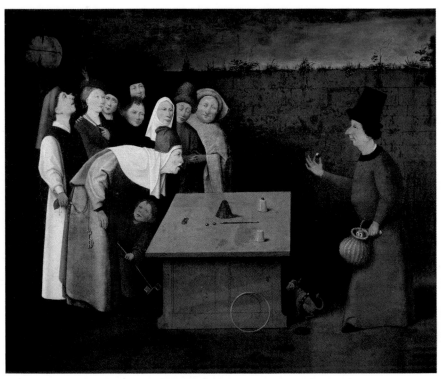

The Conjurer, Gielis Panhedel, Hieronymus Bosch van Aken
(attributed to) (1450–1516)
Late 15th–early 16th century, oil on wood, 53 x 65 cm, Musée municipal, Saint-Germain-en-Laye

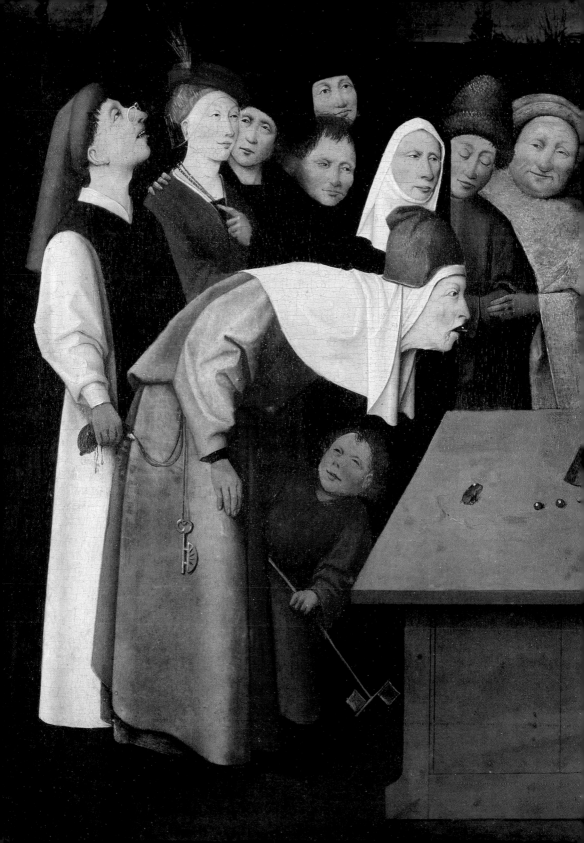

Then we notice some very odd details. The man being robbed is dribbling; the other people are almost all looking in different directions—some at the table and some at the conjurer or the tall, bent man, while others have their eyes closed. And then there is the last, forgotten member of the audience, a placid little toad squatting on the table, its eyes fixed on the conjurer's trick.

As always in the work of Bosch, this strange picture is full of symbols and has multiple meanings. But the crucial thing for us here is that this masterpiece also speaks to us about attention and awareness. Too much and too little attention are sometimes alike in that they reduce and weaken our awareness and expose us to many problems.

Keep your body still;
Keep your voice silent;
As to mind, don't bind it: let it rest at ease.
Let consciousness relax completely.
At this time, attachment to "meditation" and
"nonmeditation" clears,
And mind remains without any aim or fabrication
In self-luminous awareness, vast and transparent.

SHABKAR, *MEMOIRS OF A TIBETAN YOGI*

Awareness

We could define awareness as sensing and perceiving while knowing that we are sensing and perceiving. Awareness requires us to be awake. A sleeper senses and perceives, but unconsciously, unaware, without realizing. Awareness is undoubtedly our mind's most delicate, complicated function and has been the subject of thousands of scientific studies. But what we need here is a model of understanding that is not too wrong and not too complex. To be simple, we shall say that there are three levels of awareness.

The first is that of primary awareness, which is all of our impressions and sensations. This is a kind of animal, preverbal awareness that helps us adapt to the world around us. For example, it is with this awareness that, while reading these lines, you also perceive your body, the sounds that come to your ears, movements around you and so on.

The second level is that of identity awareness, in which the notion of the "self" emerges as a result of these impressions. It is this form of awareness that helps us synthesize our experiences and understand that all these sensations are ours. Of course we are used to this; it seems "obvious." We forget about it, but sometimes, as we pass a mirror or hear someone say our name, we have a sudden realization that sends our head spinning for a moment—"What? Is that me, that face, that person being mentioned?"

The third level is that of reflective awareness, capable of stepping back from the "self" and observing its mechanisms. This is the awareness that helps us understand and think. It leads us to realize that we have been too selfish, or that we are becoming annoyed or worried.

But what about the form of awareness we call "mindfulness"? How does that fit in? We can say that mindfulness involves fully integrating all three levels. Primary awareness is particularly important, since it enables us to understand and calm our body and emotions. Identity awareness is the starting point for observing the flow of our thoughts, while reflective awareness enables our mind to disengage and free itself from its mental reflexes.

Attention

Attention "is the taking possession by the mind in clear and vivid form, of one out of what seem several simultaneously possible objects or trains of thought . . . It implies withdrawal from some things in order to deal effectively with others," explained William James, a founder of modern psychology and one of the first to study awareness and attention.

Attention is the fundamental tool of awareness. There can be no awareness without attention. This is undoubtedly why the words most often spoken by meditation teachers are: "Now gently direct your attention to . . ." But attention and awareness are two

different things. In attention we ignore (what does not interest us), whereas in awareness we notice. Attention proceeds by exclusion, awareness by inclusion. Anxiety and depression can be understood as disturbances of the attention—we pay attention only to our sources of worry and ignore the rest. One possible solution to these problems is to use mindfulness to treat our attention sickness by expanding the scope of our attention at times when we feel sad or worried.

Quality of attention

But let us go back to attention and its relationship to awareness. It is hard for us to act directly on our awareness. Generally speaking, we do this by learning to modulate our attention. We can approach this in two ways.

The first relates to the openness of our attention. Attention can be focused (narrow) or open (wide). In focused attention we direct a narrow beam of attention, for example on an action (concentrating on what we are doing), a performance (being absorbed by what we see or hear) or our thoughts (getting caught up in our thoughts or ruminations). Open attention, on the other hand, expands and detaches itself from its initial objects, gently freeing itself from identification with thoughts or things that are sensed, to include other objects. This is what happens when, while observing what we feel in our bodies, we then include other layers of sound, thoughts and emotions

in our experience of the present moment. This more widely open attention naturally tends toward what we can also call "attentive awareness," which is very similar to mindfulness.

But in mindfulness there is something else as well. The second possible approach deals not with the openness of our attention, but its quality, whether it is "analytic" or "immersive." Analytic attention is the kind we use when we are concentrating on solving a difficult problem, be it mathematical or existential. Our intelligence is working to the maximum, our thoughts are in full flow and our reason advances as we analyze the problem in its every detail. Immersive intelligence, meanwhile, operates at a

different level. It makes us forget that we are thinking or acting. Immersive attention can occur in simple activities, such as when you are caught up in an exciting film, or following the rhythm of your steps while jogging. But it also occurs in more complex tasks, such as skiing down a slope, playing a musical instrument or focusing on an intellectual task. In all these situations we are fully attentive to what we are doing (otherwise we would fall over, play a wrong note or be constantly distracted from our thought processes). But we are attentive in a way described as "immersive"—we are so intensely present to what we are doing that we are completely "inside" it, without the need to mentalize or analyze what is happening.

The more our attention expands and is immersed, the closer we come to mindfulness—an intense, open presence that is not simply mental but complete (including our entire body) to our experience of each moment.

Working on attention
to preserve awareness

Where the life of the mind is concerned, things don't happen just because we want them to or because we have decided they should. The same is true of attention.

Work on attention was long ago identified as a necessity, in both East and West. Let us turn again to William James: "The faculty of voluntarily bringing

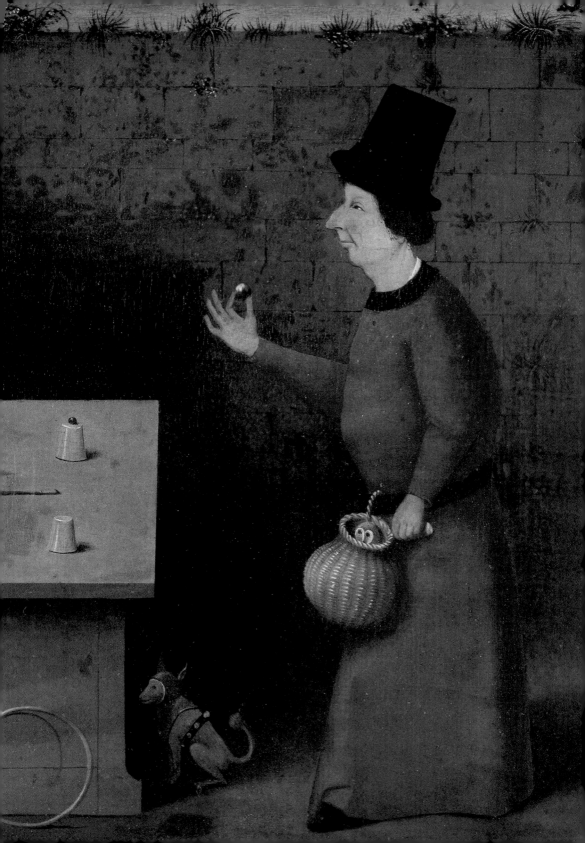

back a wandering attention over and over again, is the very root of judgment, character, and will. No one is *compos sui* if he have it not. . . . But it is easier to define this ideal than to give practical instructions for bringing it about."

The capacity for attention underpins our mental efficiency and our well-being, which tend to be weakened and reduced by contemporary lifestyles. We are increasingly living in "psychotoxic" environments that fragment our attention with constant interruptions (from ads on radio and television to the continuous flow of emails and text messages), interesting or eye-catching suggestions (there has been a documented, dizzying increase in the number of shots per minute used in films and on television). The problem is that our mind is already predisposed to distraction and fragmentation. It is drawn to things that are noisy or easy, just as our taste buds are drawn to things that are sweet or salty.

Environments of this type (and our lack of effort to counterbalance them) mean that our attention tends always to function in narrow mode. It gets used to remaining focused and jumping from one thing to another—one worry to another, one distraction to another and so on. Today it has been suggested that this narrow, analytic mode of attention functioning leads to ruminations that fuel states of anxiety and depression.

Hence, more than ever, our need to work on our capacity for attention and to protect and restore it.

From this point of view meditation can be seen as a form of attention training, preventing our awareness from being stolen from us in the future. . . .

LESSON 7

Work on attention is the core of mindfulness practice. Sit down, focus on your breath, and notice how your mind moves elsewhere. Come back to your breath. Once, ten times, hundreds of times. A long time ago hundreds of steps taught you to walk. Every day hundreds of steps maintain the ability to walk within you. The same is true of your capacity for attention. If you live in a scattered state, simply responding to invitations to anywhere with lights flashing and bells ringing, your capacity for attention will be stripped away. Mindfulness exercises, and particularly the hundreds of "exits from exercise" and "returns to the present moment," provide exceptional mental training. Practice and practice. Otherwise you can expect your mind to play tricks on you.

BE SIMPLY PRESENT

t's an amazing sound picture, but what resounds here is silence, as in every painting by La Tour. There are no words, there's no movement or sound, either in this room or nearby. It is deepest night. The only dialogue is between light and shadow, the flame and its reflection. The candle acts as a metaphor for the fragility of all human life, its reflection as awareness of this fragility. Both the candle and its reflection are surrounded by darkness. Pinch the flame between finger and thumb and there is only darkness. . . .

The objects around the candle, motionless in the half-light, are like orphans. The mirror shows no human reflection, only the candle flame. The abandoned necklace is a memory of Mary Magdalen's past as a prostitute. The skull is reminiscent of vanitas symbols and their unavoidable message: *memento mori*, remember you must die.

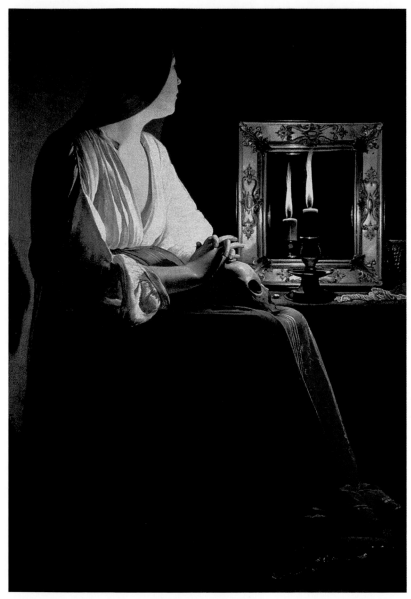

The Penitent Magdalen,
Georges de La Tour (1593–1652)
c. 1638–1643, oil on canvas, 133.4 x 102.2 cm, Metropolitan Museum of Art, New York

But do not be afraid of death. Remember that life on earth is short, fragile and pointless. Remember that what is important and essential lies elsewhere. But remember also that there is another way to live, by being aware. This is what Mary Magdalen is doing. She sits with her hair down, her red dress undone, in a plain white shirt without lace or any other form of decoration. Is this the shirt of a prisoner condemned to death? Or the shirt of someone shaking off their past and their sins. Where is she going to go? What is she going to do? Later, later . . . For now there's just the bare, calm intensity of the present moment. Mary's hands are resting on the skull. Her face is turned away from the viewer, away from the world. What is she looking at? The mirror? The candle? No. Mary isn't looking at anything; she is looking into the empty darkness of the wall above the mirror.

I lose faith in "great events"
as soon as they are surrounded by much
bellowing and smoke.
And just believe me, friend Infernal Racket!
The greatest events—these are not our loudest,
but our stillest hours.

NIETZSCHE, *THUS SPOKE ZARATHUSTRA*

Reflection

For mindfulness, we need moments of reflection. Reflection means recentering, re-inhabiting, regaining contact with ourselves, when many of our actions and environments act to cut us off from ourselves—or at least they weigh us down and lead our mind away from the moments when we feel that we exist, when we feel ourselves "being" because we have stopped "doing."

Some environments are conducive to such moments of reflection. Churches and other places of prayer, for example. When I'm early for something, I sometimes take a little time to go and meditate in a nearby church, not "far from," but "outside" the whirl of the city and the overstimulation it produces. Of course nature can also foster moments of reflection, and this is undoubtedly one of the mechanisms that make spending time in nature good for our health, as many studies have shown. Contact with nature exposes us to an environment where we find quiet, slowness and continuity—all "foods" for our mind that facilitate mindfulness.

But we can also make space for reflection amid the tumult of life if we decide to stop and step back from the action for a moment. These moments stolen from the hurly-burly can sometimes be very powerful because they represent such a contrast. Beyond their capacity to soothe our emotions, they may suddenly give us a sense of greater inner space or greater intellectual clarity. Think of a walker caught in a sudden downpour, who takes shelter under a porch. If, instead of cursing the storm, he turns his awareness to the

Reflection means recentering, re-inhabiting, regaining contact with ourselves, when many of our actions and environments act to cut us off from ourselves.

present moment and sees this hindrance as respite, a parenthesis, he will have experienced something useful and profoundly healthy and health-giving.

Reflection also has a role to play before we do something. Just before beginning a task we can stand still for a moment, feel ourselves breathe before we sit down at our desk, connecting, wordlessly and with no defined intent, with the deeper meaning of our work. We might do this before going home in the evening, visiting a friend or, for those engaged in therapeutic work, seeing a patient. In the past such moments were regular occurrences, for example in the blessing before breaking bread or the evening prayer. Where have these moments of reflection gone in our modern lives? Certainly not to the radio or television that we turn on as soon as we get home, or the screens that constantly enslave us. Rather than being ways of "taking our mind off things," these actions, particularly when they become reflexes, stop our minds being rooted—the exact opposite of what reflection is all about.

I remember a patient who was learning mindfulness meditation telling me with jubilant amazement how, on getting into his car every morning, he would follow the exercise of not automatically turning on the radio, but instead placing his hands on the wheel, breathing and noticing what he was feeling. And how these little moments, along with many others during the day, had gently reduced his anxiety.

I also remember a strange, undoubtedly auto-biographical passage in Pascal Quignard's book *Les Ombres errantes*: "Why, one fine April day in 1994, coming out of the Louvre into dazzling sunlight, did I suddenly walk more quickly? A man walking fast crosses the Seine, he looks at the water entirely covered in shimmering white beneath the arches of the Pont Royal, he sees the blue sky over the rue de Beaune, he breaks into a run, pushes through a heavy wooden door on rue Sébastien Bottin and resigns from all his functions. One cannot be at once prison guard and escaped prisoner." Mindful living is not without its risks, and reflection soon leads us to want to shed things, not in order to be poorer, but lighter.

Absence of clutter

The second necessity for mindfulness is an absence of clutter. We are not obliged to shed our past or our clothes, like Mary Magdalen, but we do need to shed some of our psychological attitudes. An important step on this path is to rid ourselves of reflexes of thought, notably expectations and judgments. Mindfulness

involves not judging, not filtering, not clinging and not expecting anything—four attitudes to cultivate in meditation exercises, and four things to give up in their wake.

Not judging means, for example, not judging whether a meditation has been successful or not. Of course this is hard to do, and in fact "not judging" is more about not giving way to the judgments that are bound to come to mind, not allowing them to take power, not staying with them, not letting them take over the space.

Not filtering often means, as we have seen, allowing bodily sensations, thoughts and feelings to exist, however unpleasant they may be. For example, we can give up the hope that no sound will reach our ears when we are meditating. We can accept discomfort. But of course we can also notice what is good and pleasant. This is not a matter of masochism or hedonism, just open, curious awareness that notices everything, but goes where it will.

Not clinging means, for example, not hanging on to what is pleasant, which is often a fundamental reflex. It means, for example, not wanting to remain, at any price, in a state of well-being we have attained by paying attention to the movements of our breathing. Why should we adopt this attitude? It isn't a matter of wishing for the pleasant feeling to stop, but of training ourselves to stop worrying about it stopping, freeing ourselves from thinking "I hope this lasts," from the anxieties that—naturally—gravitate around the loss

of something pleasant. Because it's better to savor something pleasant with mindfulness than to worry about its future disappearance. It is this "happiness worry" that so many anxious and depressed people find so hard to overcome.

Not expecting anything is almost certainly the aspect of mindfulness meditation training that beginners find most disconcerting. Not expecting anything, not hoping that the session will be a source of enlightenment or relief—"I've got to shed my expectations?! But without expectations, without goals, we'll never get anywhere!" Precisely, that's the point. In mindfulness we are not trying to get anywhere other than the place we're already in. . . .

Sincerity

Shedding our expectations is the hardest part and must not be a trick we play on ourselves (pretending to expect nothing while continuing to expect deep down), or a masochistic attitude (losing interest in well-being). It's simply a detour. All the things we could reach and construct through effort and will are things we have already reached and constructed. Conversely, many things, particularly in the emotional sphere, have resisted our control and our will. So we are going to try to disengage ourselves from the "desire to solve" in order to experience something else—the benevolent acceptance of what is there. This involves wanting nothing other than full presence to the moment. Mindfulness is all the times I feel

profoundly that I already am where I wanted to be, here and now.

Pure presence and attention with no object

By gently expanding the scope of our attention and shedding our expectations and mental filters, our awareness has become mindfulness. It has become expansive and without object. Pure presence.

Awareness with no object? This is a concept that sometimes divides theorists from practitioners. For philosophers, for example, all awareness is awareness of something. This assumes that awareness is an effort of attention focused on an object. But for those who meditate, awareness without an object is possible. They have often experienced it. It is an expanded awareness that makes room for everything. It is like boundless love for what is—seeing what is and loving it as best we can. This is sometimes also called awareness without choice. It is a precious attitude, though not intrinsically superior to other ways of being and acting. Nor is it a form of gratuitous mental acrobatics. It is precious because it is unusual, and probably carries great powers of healing, freedom and clear-sightedness.

For most of us, awareness without an object is often a transitory moment rather than a stable state. Our contact with pure presence is fleeting. And we sense that there may be something beyond. Whether this is revelation or illusion, it brings indescribable pleasure.

At first such moments are heaven-sent favors, life-lines thrown to us, often by chance. They are moments

when everything is perfect, without the slightest input from us. Then, gradually, we learn how to provoke these instances of pure presence that can be defined in very simple terms—"just being there." But they are also very hard to put into practice when we don't know how to "just be there." Taking action, directing, influencing—we are itching to do all these things and soothed by doing them. This is both the great strength of human beings and our great weakness. But every now and then we are able to hold back. We shed our surface life, set aside our past and projects. For a moment we enter a fleeting immensity and eternity, which our actions and thoughts had hidden from us. All is good and overwhelming. Quietly overwhelming.

LESSON 8

We must invite reflection into our days. Go through our daily lives regularly opening our mind to what we are experiencing. Leave behind words, thoughts, goals, actions and stop "doing" in order to "be." We must step aside, when the hurly-burly around us or within us grows too great, and shed all forms of will; for a few moments we must stop all forms of wanting and seeking, disengage from all forms of reasoning and action and simply exist, here and now. Just be aware that we are here, alive.

2.
LIVING WITH THE EYES OF THE MIND WIDE OPEN:
A PHILOSOPHY OF EVERYDAY LIFE

I haven't done a thing today.—
Why? Have you not lived?
That is not only the most basic of your employments,
it is the most glorious . . .

Montaigne, *Essays*

SEE
ORDINARY
THINGS

Y ou were passing, and you stopped. There was something special—the light, perhaps, at that time of day when night starts to cast its shadows and the glow of electric lights forms islands of humanity in the darkness. Or was it the softness of the air? Or the dark mass of the forest all around?

You notice the silly detail of the Pegasus on the illuminated sign. The big red Pegasus with its three little brothers, impatiently longing to fly up into the sky and the nothingness of night. This effigy of Pegasus strangely anchors your attention. And now you are present to all the rest of this banal, ordinary moment. You become aware of the gasoline vapors and the blandly silly tune coming from the radio that is playing somewhere inside the lighted house.

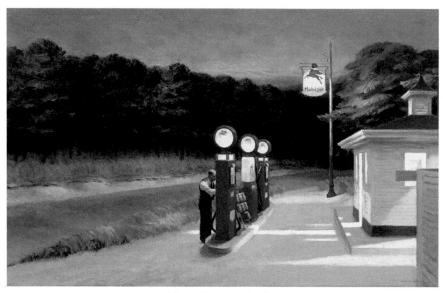

Gas, Edward Hopper (1882–1967)

1940, oil on canvas, 66.7 x 102.2 cm, Museum of Modern Art, New York, Mrs. Simon Guggenheim Fund

It's neither the beauty nor the oddness of this moment that touches you, stilling your body and soul. You don't need beauty or oddness to stop the flow of your movements, thoughts and plans. You stopped because this moment is unique. Because never again will you see exactly what you are seeing now. Because never again will you experience exactly what you are experiencing now. This is it—you have understood. You've stopped because you have realized what matters most. You are living a bit of life. How can you forget this so often? You forget that being alive is a stroke of luck, that every moment of life is a miracle, snatched from night, death and nothingness. How can you forget all that? Never forget to live. Now, for example. Raise your head and look around you with the eyes of a newborn, as though you had never before seen what you're seeing now.

Never forget that every mind is shaped
by the most ordinary experiences.
To say that something is ordinary is to say that it is
of the kind that has made the biggest contribution
to the formation of your most basic ideas.

Paul Valéry, *Mauvaises Pensées et Autres*

Switch on your awareness more often

We rouse our awareness when we encounter things that are beautiful, unexpected or overwhelming. We tend to spend the rest of the time as robots, active but absent. Sometimes we wake up. Our era scatters our lives with signposts ("Over here!" "Over there!"), from advertising ("Look! Listen! Taste! Now!") to carefully delineated moments when we "have to" be enchanted or moved (cinema, theater, museums and galleries). So many signposted certainties—yet our lives are not guided tours! If we allow ourselves to be maneuvered in this way we become hollow spirits—dead or deadened souls.

We need to love things that are ordinary and banal. We must look at them and respect them. We must open ourselves up to the density of the everyday world. Mindfulness does not need any special environment in order to happen. True, some surroundings can be more helpful or favorable, but mindfulness can come to us anywhere. As long as we make a little effort. As long as we remain awake and present.

Not *doing* but *being*

We are always busy *doing*—flitting from one action to the next. But though we're very active, we are not present to what we are doing. Our mind is often filled with intentions, or memories of other actions.

Take this painting. How many of this gas station's customers have never noticed what is shown here? How many have seen nothing at all? "I'll fill the tank, pay and drive off again. I'll get to the motel on time, it won't be too late, I'll ask for my usual room, I'll put my things away, I'll brush my teeth thinking about my day's work tomorrow, I'll set my alarm clock so I get up in time, then I'll watch whatever's on TV and think, 'I hope I sleep well so I'm in good shape tomorrow' . . ." There have been too many days when I've done lots of things, thought lots of things, but when I haven't actually lived, haven't felt alive, haven't even noticed that I'm alive. A robot.

In absolute terms it's no better to be than to do. We need both. But that's the point: *we need both*. And the mental mode that our lives leave out or are quick

to exclude, quite unconsciously, is the *being* mode. In our societies the "default" mode is *doing*. Mindfulness gently reminds us to come out of *doing* and—even for just a tiny little moment—go into *being*.

Just be here: life as an exercise in mindfulness

The instruction is simple: we must intensify our presence to these benign moments and inhabit them through awareness. We must stop being ghosts and come out of limbo, which isn't death, of course, but can be a form of nonlife. Making ourselves present means making ourselves alive. For real.

We need to observe ourselves experiencing. Here, where we are, not only in special circumstances. We should observe ourselves experiencing everyday life—even boredom sometimes. For example, while waiting or on the way to something, why not take advantage of the time to feel that you are here, and the way in which you are here? Stop *waiting* and be here! One day, during one of my conference trips, I was waiting for a train on a station platform. I was waiting for it good and proper—checking the time, scanning the horizon and wondering if it would come from the right or the left, knowing all the while that it wasn't due for another ten minutes. But I kept on wondering whether it was coming from a different station (it would arrive right on time) or whether the station I was at would be its starting point (it would be at the platform some time before and I could board it). In short, my mind was all cluttered up with unimportant,

> I focused my attention on my breathing and the way I was standing. I gently straightened up and opened my shoulders. Then I also opened my ears and listened.

pointless thoughts. Luckily I realized this (I don't always). Suddenly I saw myself waiting for my train, like a dog waiting for its dinner. And I thought, no, I can't go through my life like that, not even a little bit of my life. So I remembered my patients and the exercises of presence to the world that we regularly practice. And I just did what they do, what I ask them to do. I left the mode of action behind (or rather of going around in circles, given that I was doing nothing but waiting and checking whether my train was coming on time or late) and I went into the mode of presence. I forgot about the time and the horizon at the end of the track and I focused my attention on my breathing and the way I was standing. I gently straightened up and opened my shoulders. Then I also opened my ears and listened to the station sounds—murmurs, the sound of wheels on rails—and the conversations of the birds. I observed the light of that spring day, the slow movement of a freight train at the other end of the platform, the clouds, all the railway equipment and the

signs and buildings in the distance. I sniffed the cold smell of metal that you often get on station platforms. It was amazing how much there was to see and sense. Amazing how interesting and calming it was to be intensely there, present to my life at that moment. When I boarded the train I was unusually serene. I hadn't *waited* for it at all. I had just *lived* my life and taken nourishment from its moments.

We must take time just to be here and be aware. We must be aware that we are alive. Does that mean doing nothing? Not at all, it means living. Living in awareness, touched by ordinary things, jostled by normality. It means being enlightened by the benign and ordinary—dazzled and delighted by life.

LESSON 9

We must make ourselves sensitive and present to all the things we have stopped looking at. All the ordinary, everyday things, the things that have stopped attracting our attention. We must let ourselves be touched by the everyday instead of subjugating and trampling it unseen. We must invite the world into us and discover its subtlety and diversity, rather than seeing in it only things that reflect our current obsessions. This is easy to do; it requires just three things: wanting it (wanting to exist in the real world rather than a virtual world that is impoverished by our narrowed attention), allowing it (having decluttered our mind and expanded our awareness) and doing it (raising our head, opening our eyes and really looking).

SEE THE
INVISIBLE

They speak to us, murmuring in our ears. But what do they say? First we must stop to listen to this whispering. Then we must try to understand them. We must stop, breathe and immerse ourselves in the contemplation of the objects that make up this still life.

The name *still life* says it all—these are pictures of calm, peaceful life, which they invite and encourage us to enter. In our utilitarian, ever-moving world, still lifes give us pause. This is life without movement, going nowhere. So is it pointless then, because it has nothing to show but ordinary things? Well no, because what it shows us is precisely the ordinary things we never look at.

And when we look we see majestic simplicity. An intense presence behind the stillness. When we look we

Glass of water and coffee pot, Jean-Baptiste Chardin (1699–1779)
c. 1761, oil on canvas, 32.5 x 41.3 cm, Carnegie Museum of Art, Pittsburgh

see that even things that don't flash, move, shimmer or make a noise can be interesting and important. When we look we see that there is beauty, intelligence and even grace in things that are simple, accessible and available.

I remember a discussion I once had with a Zen monk, who advised me always to respect inanimate things. What things are inanimate, I wondered. He replied that they were "things that don't cry out when we hit them." Things, objects, all these bits of substance that never, ever cry out. But which do sometimes speak. . . .

Seek among all the poor and clumsy objects of a peasant's life for the one whose insignificant form, whose unnoticed being, whose mute existence can become the source of that mysterious, wordless, infinite rapture.

HUGO VON HOFMANNSTHAL, *THE LETTER OF LORD CHANDOS*

The lessons of things

Living in mindfulness means taking time for contemplation. Being touched by objects—the ones we encounter every day and forget because we have seen them so often that we no longer see them at all. We must let them enter into us and enter into them. We must take down the barriers between us, become them and let them capture and fascinate us, to no purpose.

By surrendering to their mute presence in a corner of our home, we understand that these objects can be sources of calm, slowness and permanence. When we move close to them and allow ourselves to become imbued with them, we can hear them murmuring to us to resist the two modern evils of activation ("Do! Do!") and acceleration ("Quick! Quick!"). "Beware the gentleness of things," says the poet Paul-Jean Toulet. Yes, because we can be swept away by this gentleness. But rather than being wary of things, let's take care of them. Let's cherish the gentleness of things—this still life will take us traveling in stillness.

Secret connections

Ordinary objects are not ordinary, they are miraculous. Water, a glass, a coffee pot, a table, a wall, garlic bulbs—all these are miraculous. That we drink, eat, make things and belong to an intelligent, industrious and curious species is miraculous. And opening our eyes to all these unfathomable, inestimable riches that we rub shoulders with every day without seeing them is also miraculous.

Ordinariness has opened us up to humanity, because we have accepted and noticed it; we have listened to it, looked at it, felt and loved it, without wanting to change it or make it more beautiful, without wanting to alter it.

Of course it takes effort—a microscopic effort of presence and looking—to see all that is invisible to those who do not look. To see that we are never alone, but a hub for thousands of connections. Other human beings made this jug and this table; they found springs and built aqueducts to supply water to quench our thirst; they realized how to turn sand into glass; they grew and harvested these garlic bulbs. A human being called Chardin painted all these miracles for us, several hundred years ago. And here we are, looking at it all, as others have looked before us, and others still will look after us. Others who, like us, will have had the experience of drinking water, will know the smell and taste of garlic and have run their hand over a tabletop.

Ordinariness has opened us up to humanity, because we have accepted and noticed it; we have listened to it, looked at it, felt and loved it, without wanting to change it or make it more beautiful, without wanting to alter it. And we have felt alive, human and happy.

We are happy to be here, in this kitchen corner, with these ordinary objects. Gently happy at these connections to nature, human beings and our history. Every benign object is a treasure chest if we look at it as Chardin enables us to do. Here's an object we were given, here's another we bought at a particular place and time. This one was invented and created by human beings on a distant continent, in a very distant past. And that one has come to us from far, far away. . . .

Presence to objects is like an awareness of humanity in and around us, a joyful debt and infinitely expanded gratitude. How, when we have felt this, can we claim to be misanthropic or puff ourselves up with pride?

Get closer to the essence of things

We can go a step further.

We can go beyond all these stories told us by the mute objects that live in the shadows of our awareness. We can contemplate them without thinking or dreaming. What is called *contemplation* is "the attitude of awareness that is content to know what is, without seeking to possess, use or judge it," as André Comte-Sponville so splendidly defines it.

Contemplation involves looking at things without hope, covetousness or comment. It means adopting a position of open, curious humility toward the world around us, and particularly toward this small, still, invisible world. It means looking at objects for what they are. Disconnecting even from what they have to

tell us. Gently disengaging from their story ("I was given it"; "I found it"; "I bought it one rainy day when I was feeling sad"), their point ("I use them for this or that"), our judgment of them ("It's beautiful"; "It's ugly"; "They're weird"). We can gently free ourselves from this mental talking, pass through it and go further still, to see things in their secret state of quiet substance and connect simply to what they are. Then we will be able to receive their lesson in silent, wordless wisdom.

Stillness reveals the invisible, as silence reveals the essence. Let's take the trouble to notice the world before claiming to understand it. . . .

LESSON 10

Let us give ourselves up to the dizzying contemplation of everyday objects—an apple, a shoe, a blade of grass, a telephone. Let's grasp, caress and observe them. First we must allow ourselves to hear all that they want to say—so much intelligence and effort has gone into making them exist, so many stories have led to their being here with us, in our lives. Then, gently, we can allow these thoughts to roll back to leave us with just the essence of the object, asking nothing more of it than its silent presence. The soothing, astounding mystery of saucepan and sponge, abandoned and forgotten by all but me. These visits to the insignificant are like tributes and thanks for my staggering luck— I am a human being, alive and aware.

SEE WHAT IS IMPORTANT

t's a good-natured, friendly assault, entirely without malice. First our eyes and then our brain are forcefully struck by a joyous deluge of form and color in the background of the painting. It's wonderful, but for our senses it's also violent and tyrannical. Our mind seems to have been taken over by the vigor of the image. We are almost obliged mentally to spin the great spiral of stripes, stars, waves and other shimmering effects. Neurophysiologists tell us that certain areas of the brain create movement that doesn't exist on the canvas. The image is intrusive, almost to the point of rudeness—it imposes itself on our awareness directly and without gentleness. But then, some might say, to avoid this we need only not look at it, not be here. It's a good thing this man is here, tall with angular features and a serious expression. He seems frozen, stiff and austere, apparently uninterested in the visual racket

Opus 217, Against the Enamel of a Background Rhythmic with Beats and Angles,
Tones and Tints (Portrait of M. Félix Fénéon), Paul Signac (1863–1935)
1890, oil on canvas, 73.5 x 92.5 cm, Museum of Modern Art, New York

around him. His eyes are turned to the beautiful white flower that looks like a lily, symbol of purity. It is all he sees. And, thanks to this, we at once understand that it's the flower that matters. Thanks to him, we understand that this fragile, white flower without color or strength is what matters. It is this flower that must be looked at and protected.

This big spiral, so noisy and beautiful, intrusive and tyrannical, is like our consumer society with its powerful shimmer. It may hypnotize and enslave us, devouring our minds, unless we turn our eyes to the flower. Unless we retain all our awareness. . . .

Ah! I need solitude. I have come forth
to this hill at sunset to see the forms
of the mountains in the horizon.
HENRY DAVID THOREAU, *JOURNAL* (AUGUST 1854)

Tumult and artifice

These times of ours can be criticized for many things, but we must acknowledge that they have one great quality: they are exciting and astoundingly rich—full of change, speed and interconnections that provide us with pleasures and possibilities that were never available to the generations that preceded us. But might not these high-speed riches conceal certain dangers? Might all the interesting, flashing, shimmering things that often form our everyday external world prevent us from noticing certain forms of inner poverty? The poets who have watched today's world emerge and grow

have long thought so. Stefan Zweig wrote of "Our new forms of life, which drive men out murderously from all inner contemplation as a forest fire drives wild animals from their hidden lairs," while Nietzsche said, "Is it not the case that all human institutions are intended to prevent mankind from feeling their life, by means of a constant dispersion of their thoughts?"

To enable our awareness to exist and develop, we need to protect it from a world that is undoubtedly stimulating and nourishing, but also overwhelming and toxic.

Pollution of the mind

There are chemical pollutants that contaminate our food, air and water, and there are also psychic pollutants that contaminate our mind, violate our inner being and disturb our inner stability. These include slogans, advertising and other commercial manipulations. Many studies have been conducted into this psychotoxic materialism, and they tell us that it causes many different types of damage—for example, stealing our attention, awareness and internality. What state is our mind in when its attention is constantly stolen? For our attention is always being captured, drawn, segmented and fragmented. It becomes addicted to all that is noisy, flashy, easy, predigested and prethought. What state is our mind in when its awareness is constantly stolen? It is cluttered with pointless thoughts, actions and content—reading the advertisements that surround us, exercising consumer

choice between the "cheap" and "cheaper," expending large amounts of energy looking for a "bargain," being crammed full of information that loops and repeats from one day to the next. What state is our mind in when its internality is constantly stolen? We are submerged by more and more external attractions and distractions. Our mind and body are tied up in empty activities. Yet, just as words need silence to be heard in, so awareness and internality need mental space to emerge in. The hard disk of our awareness is crammed with too many useless things.

For awareness is internality. The more we run after external things, the less awareness there is. So thefts of attention and awareness lead to an internality deficit. They also lead to the curtailment of our thoughts. As Tiziano Terzani says, "Today we are constantly being solicited, so our mental world is never at peace. There is always noise from the television, the sound of the car radio, the ringing telephone or the advertisement on a passing bus. We are unable to have long thoughts. Our thoughts are short. Our thoughts are short because we are very often interrupted." Our thoughts are short and seldom turned inward. Instead they seem to be held captive by the tumult and shimmer of the artificial world. They are outside us. In the end our thoughts cease to be our own; they are no more than stereotypical mental content coming to us from outside, echoes of a soulless world. In the words of writer Louis-René des Forêts, "Superabundance has nothing to do with fertility." Our minds lose their fertility by allowing

themselves to be too often filled by the emptiness of this external racket.

So of course, when we try to think and practice introspection, in other words to think in a sustained way by ourselves, in peace and silence, we can't, or have forgotten how. Worse, as we have lost (or never acquired) the habit, we fall prey to anxiety, boredom or circular ruminations. So we quickly leave the world inside us to return to the outside, with its reassuring, space-filling tumult. Consequently, we suffer from a generalized internality deficit. For our society is lacking in everything that enables introspection, rendering us deficient.

Deficiencies of slowness, quiet and continuity

Sickness due to a deficiency is insidious. If we are deficient in vitamin C or D, omega 3 or selenium, at first nothing happens. We aren't in pain, we don't have breathing difficulties, we don't fall over backward. There's no immediate effect. But gradually the deficiency causes symptoms to appear. Often we don't understand why they are there or what is causing them. Deficiencies always manifest themselves gently, slowly and insidiously. Never noisily.

Our society of multiple forms of abundance also creates multiple deficiencies within us, and the two are linked. Think of diseases of excess, for example, those modern maladies of *too much*—too much food that makes us obese, too many possessions that make us morose. Too much of something is always a lack of

Mindfulness helps us to become aware of all this hidden pollution of our minds, and protect ourselves against it. It enables us to restore our capacity for introspection and reconnect with ourselves.

something else, and excess always generates deficiency. We know, for example, that industrially produced, refined, aseptic foods are not only unhealthy because they are "too much"—too present, too accessible, too sweet, too stimulating to our appetites, leading to diabetes and obesity—but also because they have "not enough" of many vitamins and minerals. Contemporary deficiencies also apply to our psychic needs, such as the need for calm, slowness and continuity. We must strive to ensure that we obtain these in order to stop ourselves falling ill (from stress, emotional instability and mental fragmentation).

Combating a lack of slowness means taking our time, not flitting from one activity to the next, not doing several things at once. Instead we must act calmly and gently whenever possible, restoring ourselves with a dose of doing nothing, drawing on the healing powers of simplicity, calm and one activity at a time. We must learn to identify timetable fillers—the packed activity

schedules we sometimes adopt at weekends or on holiday—and avoid them wherever possible. We must combat tranquility deficiencies and flee assaults and requests, resensitising ourselves to all the "too much" in our lives—the constant music, images and screens. We must unplug. As an act of freedom, we can just close our eyes and stop watching the screens that steal our attention, constantly eating into our brain time and moments of rest. Combating deficiencies of continuity means identifying and becoming more aware of the endless interruptions that punctuate our days, so that we resist the temptation to look at our emails and texts, make a phone call or go on the Internet.

Mindfulness helps us to become aware of all this hidden pollution of our minds, and protect ourselves against it. It enables us to restore our capacity for introspection and reconnect with ourselves, rather than sustaining ourselves with a constant drip-feed of external orders, distractions and activations.

Mindfulness suggests we do nothing but just be here, at our observation post, alert to introspection. Practicing mindfulness helps us disengage—we're not seeking anything; there is no goal. We take time, we freely decide to do things slowly. We take the time to sit down, observe and feel.

Even if we do this for just a very short time, a few moments, we are in mindfulness as soon as we close our eyes and stop being active. We are already free.

Meditation practice, where we make a choice between what is urgent and what is important

Just as the sedentary nature of our modern societies has created a need for exercise in our bodies, so overstimulation awakens a need for meditation in our minds. As we have seen, mindfulness can help us come closer to our fundamental needs for slowness, calm and continuity. It is important for us to meet these needs—not urgent, important.

In our lives there are things that are urgent and things that are important. It's urgent for me to answer my emails, finish my work, do the shopping and fix that dripping tap. If I don't do what's urgent I will be punished—soon I'll have problems. So I do it. It's important that I walk in nature, watch the clouds passing, talk to my friends, take the time to get my breath back and breathe, do nothing and feel alive. If I don't do what's important, nothing will happen to me—at least not immediately. But gradually my life will become drab, sad, or strangely lacking in meaning.

Every day the things that are urgent in our lives come into conflict with those that are important. How can we stop totally sacrificing the important things to those that are urgent? How can we stop bowing ever more fully to the dictates of the urgent, with the effect that, after a while, every demand seems urgent to us, even when in reality it isn't, or not as urgent as it would like us to think?

By thinking, of course, and meditating.

But even when we practice mindfulness, we are constantly exposed to the same conflicts. Hardly have I sat down and closed my eyes, when I'm already assailed by thoughts of all the things I have to do. "Remember to send that email. Don't forget to call So-and-so. Oh, you need to make a note of that idea before you forget it. Instead of sitting here trying to meditate, you should get up and go and do all those things before you forget. Besides, your meditation's not going so well today, your mind isn't on it. So just stop trying and get up. You can do it another time. Meditating can wait, your job can't. . . ."

Things that are urgent always try to take up the little space I strive to keep for important things. They can't help it, it's the way they are. So if I don't say no, if I don't make the effort, I'm lost. I shall live the nonlife of a busy, empty robot. Is that what I want?

Mindfulness reminds me to protect important things. To say softly to myself, "No, I'm not going to get up, I'm not going to open my eyes, I'm not going to stop meditating. I'm going to sit here with my eyes closed and be aware of my breath and the breath of the world all around me. It's important. Very important. Infinitely important. Nothing is more important right now than to sit here like this." Having learned to say a gentle "no" during mindfulness exercises, having *experienced* this no and its benefits, the effect will gradually spread to the rest of my life, helping me to say no there too, helping me stem the flow of urgent things and more

clearly identify false alarms urging, "Quick! Do it now!"

I smile, understanding that each time I win one of these little fights it makes me more intelligent and happy, and gradually helps me make space in my life for what matters. And I think of Thoreau, who spent a year living in the woods in Walden: "When he has obtained those things which are necessary to life, there is another alternative than to obtain the superfluities; and that is, to adventure in life now."

LESSON 11

We must constantly shield our mind from the intrusions and demands of "modern life," which means, among other things, shedding reflexes such as automatically turning on the radio, TV or computer. We must set aside, and jealously guard, periods of continuity for our mind (not allowing ourselves to be disturbed or interrupted by the phone and other messages). Calm and silence should be regarded as indispensable nourishment for all active city-dwellers, the lack of which will gradually make us ill if we let it go on too long.

ACT
AND DON'T ACT

This is going to be a beautiful wood floor! The walls are already finished, white with gilded plasterwork in straight lines, joyfully offset by the arabesque curves of the balcony. The three workers are quietly getting on with the job, with a concern for detail and work well done. Look at the one on the left, wielding his chisel with delicate precision. Meanwhile his two colleagues exchange a few words while getting on with their planing. Are they talking about the beautiful floor they are creating from the rough planks of wood? Or their wages perhaps? Or Sunday, when they plan to go boating on the Marne at Nogent? Or love, the elections, life in general?

In this picture Caillebotte has painted different relationships to action—attentive, automatic, solitary and shared. He also suggests that soon the action will stop, when these brothers in flooring take a well-deserved pause in their work to enjoy a glass of wine amid the combined scents of sawdust and sweat.

The Floor Planers, Gustave Caillebotte (1848–1894)
1875, oil on canvas, 102 x 147 cm, Musée d'Orsay, Paris

When I dance, I dance; when I sleep, I sleep; yes,
and when I walk alone in a fine orchard, if my thoughts
have been occupied with extraneous matters for some
part of the time, at another moment I bring them
back to the walk, the orchard, the sweetness of this
solitude and to myself.

MONTAIGNE, *ESSAYS*

Meditation needs action

Should we remain still and cut off from the world? Yes, mindfulness exercises are like that. But only for a while. They are a moment's breath between two periods of action. We always return to action in the end. Meditation itself loves action, otherwise it goes around in circles. We meditate before acting, after acting and even while we are acting. It's possible to complete an action, or not, in mindfulness.

We should always be wary of ideas that are not rooted in action; they are like those fruit and vegetables grown hydroponically, which are not rooted in earth but cultivated under glass in an artificial feed solution unrelated to real soil. We should always be wary of theories developed by human beings who are not routinely engaged in action. "Whoever makes it a rule to test action by thought, thought by action, cannot falter," said Goethe. Nor should we make action the slave of thought. We must not carry out an action thinking only of its goal ("Is it nearly done? It's taking such a long time!") or endlessly judging it ("This is nice"; "This is such a drag!").

We must set action free, regularly allowing it to be simply what it is.

Freeing action: the "just" approach

Let us free our actions and give them density, allowing them to be "just" what they are—just eating (without reading or listening to the radio), just walking (without making a call or looking forward to something else,

without thinking), just listening (without formulating responses or judging what's being said to us). Despite appearances, "just" doing is supremely difficult. We are often tempted to do several things at once—we read as we eat, or make a call as we walk. Or, inside our heads, we do something while thinking about something else (taking a shower while thinking about our day at work). This means we are totally absent to what we are doing, and that's the opposite of mindfulness.

Mindfulness requires a simple approach to action—not all the time, but on a regular basis. It recommends that, once a week, we have a meal in mindfulness (in silence, without reading, or radio or conversation). Or that we often walk in mindfulness—gently, slowly, feeling our body walking, and that it is walking in an environment that we allow to enter into us, in a sea of sensations whose touch we feel in our being. Just walking. Just doing the dishes and putting the trash out, without complaining or rushing and in mindfulness. . . .

The virtues of presence to action

What's the point of making ourselves do this? Why should we abandon the idea of living two lives rather than one, of doing two things all the time rather than one? Because in trying to live twice as much we risk living half as much, because we make our life twice as bad—twice as sad, twice as irritated, twice as empty, twice as pointless.

It's important to get away from frenzied goal-

orientation. We should not act only to *do*, but also simply to *be*. Mental presence to action increases our sense of being real human beings and our presence to the world. It enables us to avoid those mechanical actions that we can't even remember having done a few minutes later. Mental presence to action also enables us to get closer to the point of why we are doing something. Being present to what we eat will make our food tastier. Listening to someone speaking to us enables us to truly listen, rather than judging them at the same time, or simply pretending to listen when in reality we're thinking of our own response.

Mental presence to action allows us to understand better when something we are doing becomes pointless. Being present to what we are eating or drinking helps us feel when we no longer need to keep on eating or drinking. Mindfulness helps us perceive the moment when a conversation becomes a dialogue of the deaf; it helps us know when to speak and when to remain silent. . . .

Disobey impulses

In an earlier chapter we looked at our impulses to interrupt our meditation sessions in order to do something "more urgent." This can also happen when we are working (particularly if the work is complicated, boring or stressful)—we suddenly feel an urge to check whether we have received an email or a text, to make a phone call, go for a coffee, have a chat with colleagues or eat a sweet or a cake. . . .

Mindfulness recommends that we pay attention to the emergence of these impulses before we obey them. It suggests that we "defuse" from them. That we notice them—"Oh, I feel like interrupting my work"—observe them—"It's pushing me to stop what I'm doing, because it's hard"—and wonder whether or not to obey them—"Is it important, interesting or necessary to obey this impulse?" Often, of course, it is neither important, interesting nor necessary, it's just a habitual impulse to act, act, act. Or to escape, to go somewhere else when things get difficult, when we're excited or stimulated by an idea, when we are bored, or even when everything's fine, just because it's an ingrained habit; just because, as soon as we feel the itch of impulse, we relieve it with action.

Perceiving the emergence of these simple impulses more clearly will help us cope with others that are more complex—attacking when we are hurt, ruminating when we are sad, worrying when we are unsure. The simplicity of mindfulness quietly helps us to steer our way more smoothly through life's complexities.

Learning to disobey ourselves is a simple act of personal clarification and liberation. . . .

Don't act

What if we allowed our mind to breathe more often between actions? After I've made a phone call, instead of immediately making another I can pause, close my eyes a moment, feel my breath and think over what has just been said. After my friends have left, rather than rushing to clear away before I go to bed, I can pause, close my eyes a moment, feel my breath and think over those moments of conversation and affection. After a conflict with someone close to me, rather than covering over my pain and my feelings with another action, I can pause, close my eyes a moment, feel my breath and think over what has been broken in this relationship that I hold dear.

What if, after our actions in mindfulness, we also learned to be fully present to not doing anything? We can interrupt our actions for reasons other than exhaustion, to practice nonaction.

In meditation, the practice of stillness teaches us a great deal about the notion of nonaction. When we are sitting still, in an attentive, receptive attitude,

we understand that this stillness must not in itself be another action. We understand that it must not be *willed*, forced or imposed on our body, but simply *allowed*. We try to allow it to emerge from our body, not as a result of control but through abandonment and observation. Observe this thought that tells you to move, scratch your nose or get up. Observe it well and decide whether you really want to go along with it.

At any rate, don't go along with it straightaway. Whatever happens, make it wait a little. And remain still. "Stillness is not another action, imposed on a part of my body, but a nonaction of all my being," recalls a teacher. And that's just it—the stillness in which our awareness can breathe is the result of abandonment rather than coercion. . . .

Nonaction and freedom

But giving oneself up to doing nothing is really hard! It may seem simple, but it's not simple at all. There are so many things around us and so many human beings calling out to us—so many that we could spend our whole lives responding to them. We could easily die without ever having lived, having spent our whole lives doing the things that need doing. This is why we need nonaction.

Nonaction is the breath of action. It's like the silence after noise. It means making the effort, at regular intervals throughout the day, not to move on immediately to something else, another action. It means deciding to take time, not to think, but to feel,

to allow ourselves to be gently filled with the wake of what we have just done, and with the present moment.

Lastly, mindfulness allows us to be considerably more free. The more I practice, the more I will feel the difference in my everyday life between reacting (blindly, to impulses) and responding (aware of what I do). And the more I will prefer to respond to what everyday life asks of me, aware of what I do, rather than absentmindedly reacting. This is why meditation practices can profoundly transform our relationship to the world, and also why they are related to what some call a "citizen's internality."

LESSON 12

We must develop the habit of being present to what we are about to do. Before working, eating or calling someone we love, we should take time for a few mindful breaths and quietly connect to the action we're about to undertake. This is not a matter of grand speeches or complex motivations, just a simple act of mental presence. And then, of course, every day and every week, we should practice "just" exercises—just eating (a meal in mindfulness), just walking (a journey without thinking or anticipating), just brushing our teeth (without mulling over the day's events or anticipating those of tomorrow).

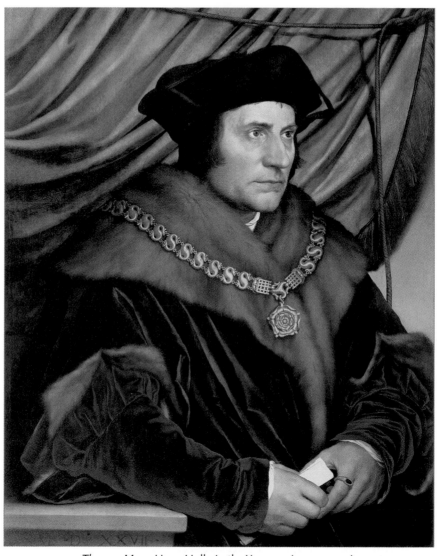

Thomas More, Hans Holbein the Younger (c. 1497–1543)
c. 1527, oil on wood, 74.9 x 60.3 cm, The Frick Collection, New York, Henry Clay Frick Bequest

SHARPEN
YOUR MIND

Calm, attentive eyes in an attractive, quietly intelligent face, expressing neither benevolence nor hostility, just a desire to understand correctly and in detail. This is Thomas More, amazingly alive in this vibrant portrait painted five hundred years ago. An eternity. This painting by Hans Holbein, who was his friend, emphasizes More's sharpness of mind and his ability at once to engage and step back. He was one of the world's movers and shakers, an important, powerful person—look at his rich attire and the gold chain attesting to his services to his king. He holds a small piece of paper, perhaps as a sign of his intense intellectual activity. He was also a brave humanist of great integrity, a reformer and visionary, the author of the famous book *Utopia* and a friend of the great philosopher Erasmus. He was an affectionate, attentive father, an unusual thing in his day. In a letter to his daughter Margaret he

wrote, "For I assure you that, rather than allow my children to be idle and slothful, I would make a sacrifice of wealth, and bid adieu to other cares and business to attend to my children and my family, amongst whom none is more dear to me than yourself, my beloved daughter." Until her dying day Margaret preserved her father's decapitated head.

Because, having been a great statesman, More was sentenced to death for his opposition to King Henry VIII of England, a tyrannical ogre who ate only meat and changed his wife as readily as he changed his shirt. Look carefully at his face—see how his left eye is soft with compassion, his right eye sharp with attention. May we all be like Thomas More, always capable of both.

If you are a poet, you will see clearly
that there is a cloud floating in this sheet of paper.
Without a cloud, there will be no rain;
without rain, the trees cannot grow:
and without trees, we cannot make paper.
The cloud is essential for the paper to exist.
If the cloud is not here, the sheet of paper cannot
be here either.

THICH NHAT HANH

Meditative intelligence

Pascal used to say that there were "two excesses: excluding reason and accepting reason alone." Reason and meditation go well together. The latter allows the former to range more widely. Mindful meditation does not soften the mind, it is not passive contemplation. On the contrary, it feeds our intelligence.

Exerting our intelligence means making connections, linking ideas and concepts and coming to conclusions or decisions as a result. But it also means seeing that these connections can or do exist. So being intelligent means starting by observing what is, rather than trying from the outset to impose our presence on reality. Intelligence is first of all connecting with the world, before linking its different elements and developing rules and laws from them.

This connection between the world and ourselves lies at the heart of mindfulness, the practice of which is at once a laboratory, where we can observe the workings of our mind (we can talk of a "science of the self"), and a gym, where we train it to acquire certain qualities— capacities for reflection, concentration, resistance to distraction, creativity and mental flexibility.

For example, mindfulness facilitates what psychologists call *accommodation*. The notions of assimilation and accommodation were identified by the Swiss psychologist Jean Piaget. They describe the way that our mind integrates potential contradictions between the world and our vision of it. So, if an element of reality contradicts one of my beliefs, I can *assimilate* (dis-

So being intelligent means starting by observing what is, rather than trying from the outset to impose our presence on reality.

tort reality to make it fit my beliefs) or *accommodate* (modify my belief to integrate the reality).

Here's an example. I think someone I know is self-ish (belief) and then one day I see them behave altruistically toward me (reality). I can *assimilate*—not changing my judgment of this person and explaining their behavior by thinking they are acting in a calculated way. But I can also *accommodate*, thinking they are also capable of generous behavior and, if not radically altering my judgment of them, at least softening it, or suspending it temporarily ("I'll wait and see what happens next before deciding what to think").

It's easier and more comfortable to assimilate than to accommodate, because assimilation does not require any psychological effort or challenge to our beliefs; it simply lubricates our mental reflexes, but clearly it does so by impeding our ability to free ourselves from our beliefs and develop our opinions and judgments. An increased ability to accommodate is one of the benefits of mindfulness. It is a consequence of mental attitudes such as acceptance and nonjudgment and, crucially, their regular practice by means of exercises. For practice

is what makes the difference between a position held in principle and its day-to-day application.

Freud said, "Conflict is not abolished by giving one [tendency] the victory over its opponent." Mindfulness can teach us not to want the victory of any of our ways of understanding or seeing the world, but to give them room within us in all their wealth and complexity.

Become calmer and understand the world better

Another benefit of mindfulness is calm, which is also very useful to intelligence. The intelligence of people who are irritated or excited can at times be dimmed to an astounding degree. Their emotions do give them power and energy, but of course they also affect their lucidity, causing these people to suffer extraordinary and recurrent failures of insight. The chaotic tumult in our mind reduces our free will, making it a slave to our emotions, in other words to circumstance.

In this regard it's interesting to note that Buddhist meditation, in which mindfulness has its origins, follows two paths. One is *shamatha*, the calming of the mind, the other *vipassana*, translated variously as "seeing deeply," "clear-seeing" or insight. The first path is necessary to allow the second to be exercised in full. An agitated, fragmented mind cannot look on the world with lucidity. It remains caught in a representation of the world, rather than being in the world. Its intelligence is thus, literally, blinkered— limited and restricted. What use is that?

Mindfulness helps us not to be content with the "mirage of reality." Insight enables us to probe into the nature of things, to avoid being misled by appearances. The philosopher Simone Weil wrote, "Intelligence has nothing to discover, it has only to clear the ground." We often have to clear our minds of all that impedes a clear, detailed vision of the world, which will then emerge of itself, as something obvious. For Buddhist thinkers the quest for insight is not a theoretical or philosophical question. The way that we see and understand reality strongly influences our well-being and, if it is inadequate, causes much of our suffering

and that of the world. Many fundamental concepts are grounded in this search for clear-sightedness. The most important include interdependence, emptiness and impermanence.

Interdependence, emptiness and impermanence

The interdependence of everything reminds us that nothing on earth has absolute existence as a fixed, isolated entity. I don't exist as an autonomous subject, independent of my environment. I owe my life and its continuation to an infinite number of other people, along with many other natural phenomena. The acts and judgments I call mine—"my" acts and "my" judgments— and which seem to me to stem from my own will, are in reality determined by many other factors. But these relationships of dependence are also relationships of interdependence—"I" am at once the endpoint and the starting point for impulses and initiatives that, in turn, influence the world around me. As long as I have not understood—and, crucially, fully recognized—all these relationships of interdependence, as long as I have not joyfully accepted them, I will be unable to see things clearly and will regularly fall into the traps of ego, pride and suffering. Accepting them, on the other hand, will not make me fatalistic, but will teach me humility in relation to my own undertakings and beliefs.

Emptiness is the second of these great Buddhist concepts, and perhaps gives rise to the greatest number of misunderstandings. The "emptiness of everything" does not mean that nothing really exists.

It simply means that what we see has no concrete, solid existence. We can use a rainbow to illustrate this idea. The rainbow's existence depends on my position, that of the sun, and the assistance of passing clouds. It exists for me, but not for other human beings in different places. The same is true of the great bitterness I may feel toward someone who has said something nasty about me—it's real enough, I can feel it filling my body and mind. But if I find out that the dreadful thing I'd heard about was in fact never said, and that the person had actually been very complimentary about me, what happens to all that fearsomely solid bitterness of the moment before? It vanishes in an instant. The emptiness of a phenomenon or thing is not describing its nonexistence or absence, but its nature as something unstable, shifting, subjective and complex. This is what emptiness is—an awareness of the complexity of everything. And its consequence is caution before we allow ourselves to be carried away and start clinging to the "mirage of reality." Though it may initially make us feel insecure, even depressed, the idea of emptiness—and crucially our experience of

I don't exist as an autonomous subject, independent of my environment. I owe my life and its continuation to an infinite number of other people.

it during meditation—gradually becomes illuminating and almost joyful, in the same way as interdependence.

And then there's impermanence, which we shall return to later and which teaches us that nothing lasts forever and that everything that happens is a matter of composition and decomposition, organization and disorganization, all of it transitory and ephemeral. There's nothing distressing about this either—on the contrary, it is illuminating and liberating.

As Paul Valéry observed, "The mind flits from one silliness to the next, as a bird flits from branch to branch. It can do nothing else. The main thing is not to feel stable on any one of them." Our minds need transitory certainties, just as birds need branches. But if we test them against interdependence, emptiness and impermanence, we will suffer less, and cause others less suffering too. For there is a fourth concept that is central to Buddhism, and without which the first three are nothing. This is compassion and altruistic love, which we shall also say more of later.

Encountering reality

The Buddhist master Thich Nhat Hanh teaches, "Meditation is not evasion; it is a serene encounter with reality." This serene encounter with reality cannot be had to order. It must be worked at through each exercise in which we use our breath to calm ourselves and patiently examine our experience of the moment, with gentleness and determination, even if that experience is painful, complicated and confused. We

keep on breathing and looking into ourselves. We accept that we do not clearly understand or control, but we keep on feeling and observing. In this way we learn to look more clearly outward, at this world that is also painful, complicated and confused. We learn to think better, more accurately and clearly. . . .

LESSON 13

We must loosen the chains of our intelligence, which can also become sclerotic, going over and over the same ground, a victim of our laziness and the invisible power of mental reflexes and "ready-made" thoughts. We can't do it to order, but we can work on it. How can we keep our mind sharp? By keeping it calm and open to the world, of course, and also by endlessly questioning its workings. Every time we find ourselves thinking, "that's just what I think," "I think I'm right," or "that's only my opinion," not as a superficial front but with real humility and real caution, we are seeing more clearly and acting with intelligence.

UNDERSTAND
AND ACCEPT
WHAT IS

F or her we don't exist.

She's not looking at us, but her gesture causes us to stand still in fascination.

There are thousands of Annunciation images in Western painting. But this one is different. It doesn't show us the Angel Gabriel coming to announce to Mary that she's pregnant; all we see is Mary's inner experience. This is a human Mary, captured in the course of her psychological journey, rather than a divine Mary, already caught up in mystic revelation.

The painting shows the precise moment that Mary understands and accepts. She accepts everything, in a single instant. It's a moment of transition, reflected in the page of the book she has left half turned in order to gather

The Virgin Annunciate (L'Annunciata), Antonello da Messina
(c. 1430–c. 1479)
1474–1475, oil on wood, 45 x 35 cm, Galleria regionale della Sicilia, Palermo

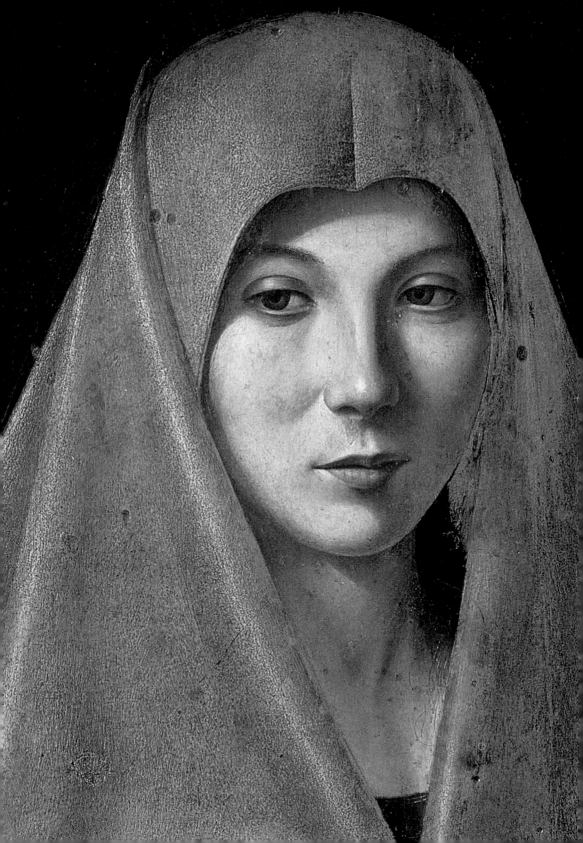

her veil around her, as though to protect herself against the destiny that has just opened up before her. Her face too is like the book, neither open nor closed. She is thinking, feeling and breathing.

There is also the strange gesture she makes with her right hand, which we shall consider further. Her hand is gently raised as though saying, "Okay, yes, yes, I understand, I accept and I will take on all that God is sending me." Her hand is still open, receiving, expressing calm, or a quest for calm, and suggesting the moment of transition in which we first accept before engaging with what is to come.

Could she have said no? Who could say no to an angelic herald sent by God the Father? Still, she could have submitted with less grace and intelligence. Mary leaves surprise, fear and disbelief behind to accept the divine will. It is this precise moment that is painted in this picture and it says everything. No angel, no trumpets, no fanfare. Just an all-consuming inner adventure.

<div align="center">

Accept!
For there is nothing else . . .
SWAMI PRAJNANPAD, *L'EXPÉRIENCE DE L'UNITÉ*

</div>

Accept

Acceptance is fundamental to mindfulness. By acceptance we don't mean thinking, "all is well" (that's approval), but "all is here, all is already here."

We don't need to like a thought, situation, person or experience in order to accept it. Like it or not, I can still accept that this thought, situation, person or experience is here, they exist, they are already in my life and I will have to work and go forward with them.

Acceptance is a higher degree of letting go. For it is an existential decision rather than just a type of behavior; it is a philosophy of life, a permanent, considered attitude to the world and the unfolding of our days. In letting go there's an idea of giving up—we stop fighting. In acceptance there's an intention to remain present in action, but differently, with lucidity and calm. To each thing that arrives we begin by saying, "Yes, it's here, it's already here. So yes." It is a sincere, total receptiveness to reality as it presents itself to us.

But this receptiveness that says *yes* in no way signifies resignation or giving up the idea of acting and thinking. It's just one of the two regular phases in which our mind works. We can see it as a form of spiritual respiration, in which acceptance (what is) is followed by action (on what is), and then acceptance (of what has happened), and then action (on what has happened), and so on until the end. As with every psychological attitude we fully master, after a while it becomes second nature. "It's not for you to accept things, they are already there." At this point we no

longer need to make an *effort* to accept—it has become an unostentatious, silent, inner ability. And we feel much stronger for it.

Acceptance as a detour

Acceptance teaches us to follow the best path to get where we want to go. And this path is not always a straight line. It's like a mountain walk, where trying to walk in a straight line up to the summit would be a bad idea. Instead we follow paths that wind their way up the mountain slopes, without abandoning the idea of getting to the top. We accept the slope and the roundabout path, but we keep climbing upward. Similarly, many psychological undertakings can be successfully conducted only through the path of acceptance.

By way of an example, take dealing with thoughts of failure ("I'll never do it"). It isn't always effective to start by countering these with our will ("Yes, I must do it!") or rationalization ("There's no reason why I shouldn't do it"). Such approaches will never enable us to learn to cope with these thoughts of failure within us (and it's better to learn to disobey them than to try to suppress them), so they will retain all their destabilizing power. In addition, we will not have accepted the idea that failure is always possible. On the other hand, the detour via acceptance often has an illuminating and paradoxically soothing effect: "I know, I accept, I'm not sure it'll work. But I still want to do it. So I'll do my best and see what happens."

Mindfulness teaches us to learn to make this detour through acceptance—to accept the idea of failure, observe its impact on us, not feeding it or giving it energy by combating it or rejecting it, but allowing it to settle within us, while we continue to breathe and to keep our attention as widely receptive as possible, remaining in mindfulness. Then we come back to action, which will often be our only means of checking whether our idea of failure was correct—or not.

Acceptance as wisdom

"A good place to look for wisdom, therefore, is where you least expect to find it: in the minds of your opponents." This is right and true, isn't it? But for this we must have listened to our opponents, and given them the right to exist (we who dream of having only "approvers"). Then their opinion becomes valuable and offers us an opportunity to become more intelligent.

Acceptance also enables us to take on board the tragic dimension of reality, without turning our own life into a tragedy. We don't deny the painful or unfair aspects of existence, we make space for them. We don't give them all the space—of course we keep some of it for things that are good and beautiful.

The word *acceptance* can be disturbing, as many people hear it as *resignation*, so substitute words have been found for it. For example, the philosopher Alexandre Jollien suggests *assumption*. Aside from its Christian significance (the Assumption refers to the miracle in which Mary was carried up to heaven

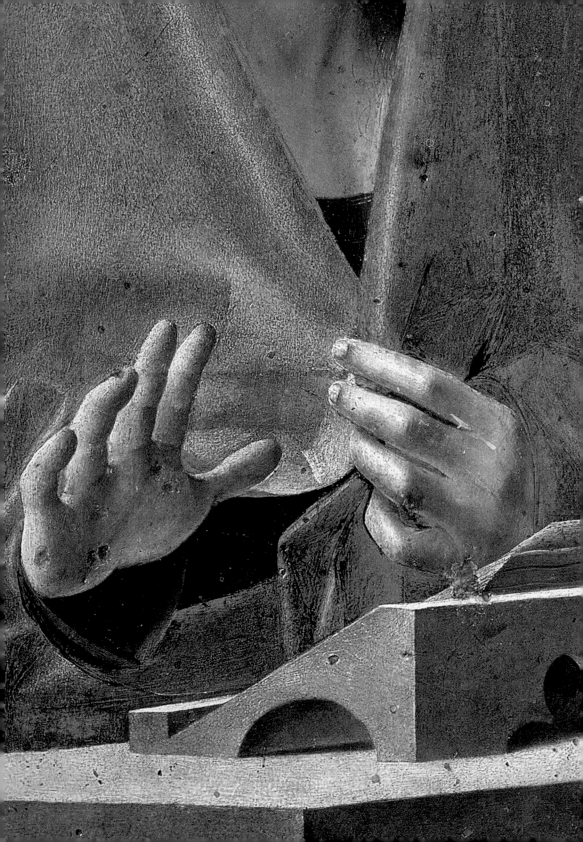

Accepting means enriching ourselves and allowing the world to come into us, instead of trying to make it in our own image and take from it only what suits and resembles us.

by angels), the word also refers etymologically to the "act of taking," of taking on and ultimately accepting. Others speak of "expansion"—acceptance does indeed involve endlessly making space within ourselves, even for things that disturb and bother us. We must never resign ourselves to them, but nor should we cling on to them negatively through rejection. Rejection and antipathy, like fear, engender dependency and vulnerability. So yes, we must endlessly make this space within ourselves and dilute our torment and antipathy in a container of infinite size. The more we feel stiffness and rejection toward what comes to us, the more it is important for us to turn toward a vast awareness without object, receiving everything.

In the end, acceptance requires a paradoxical choice—the choice not to choose! To reject or rule out nothing, even things that are "not desirable," "not good" and "not beautiful." On the contrary, we decide to receive everything, to give space to what happens and

what is. Through acceptance, we open up an infinite inner space, because we have given up the idea of filtering, controlling, validating and judging everything. In this light, accepting means enriching ourselves and allowing the world to come into us, instead of trying to make it in our own image and take from it only what suits and resembles us. As St. Thérèse of Lisieux put it in her own strange way, "I choose everything."

LESSON 14

Accepting what is makes us calmer, more intelligent, and therefore more able to change what should be changed. At least that's the idea. Then of course comes practical work, without which all this is just hot air. All our little everyday irritations are wonderful opportunities to work on acceptance. Have you been disturbed, hindered or crushed? Start by breathing and being aware of all that is there—the situation and its impact on you. Then observe that it is already there. You can't undo it, so accept it. Lastly, look at what you can do or think. All this is easy to understand and yet people have been telling us the same things for over two thousand years, no doubt because understanding is not enough. We must train ourselves in acceptance every day. This is less prestigious or enjoyable than grand speeches and generalizations, but much more effective.

3.

PASSING THROUGH STORMS:
THE PRESENT MOMENT AS A REFUGE

*He who sees the present moment
sees all that has happened from all eternity,
and all that will happen throughout infinite time.*

Marcus Aurelius, *Thoughts for Myself*

ESCAPE
YOUR MENTAL
PRISONS

P oor man! He looks so sad, worried and worn out—he seems to have given up trying to understand or do anything. Rather strangely, it also looks as though he's got his head stuck in the window. Perhaps he was trying to take his mind off things by looking out for a glimpse of what was going on in the world, to get away from his sad ruminations for a moment. And here he is blocked, suffering and passive, not looking *at* anything, just looking without seeing. His gaze is turned inward rather than out. It too has become mired in his sufferings and sorrows.

He's imprisoned, just as we are sometimes imprisoned in our thoughts. He's held captive by the rigid stone window frame and the solidity of wood, glass and metal,

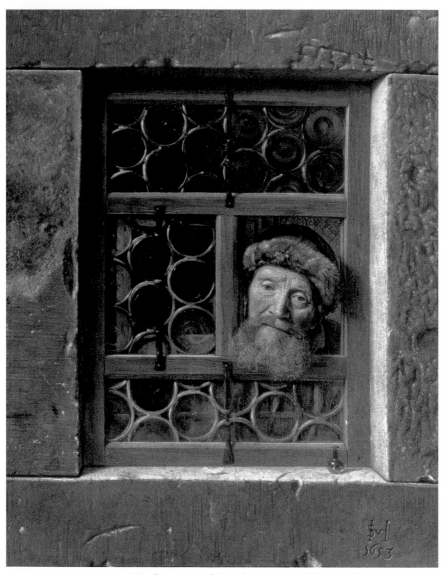

Man at a Window, Samuel Van Hoogstraten (1627–1678)

1653, oil on canvas, 111 x 86.5 cm, Kunsthistorisches Museum, Vienna

just as our worries hold us captive when they're solidified by our ruminations. This trompe-l'oeil seems to be telling us, "Look! See how your thoughts and ruminations deceive your awareness. If you engage with them, you'll find yourself locked inside them. If you feed them, they'll become as solid as reality. If you don't look out, they'll imprison you."

How can we free ourselves from self-generated torment? How can we disengage ourselves from the mind-traps in which we sometimes catch ourselves? Perhaps the solution lies in the tiny flask on the windowsill—it might contain a magic potion. But how can we reach it?

A multitude of petty ills beset you
more than the violence of a single one,
no matter how big.

MONTAIGNE, *ESSAYS*

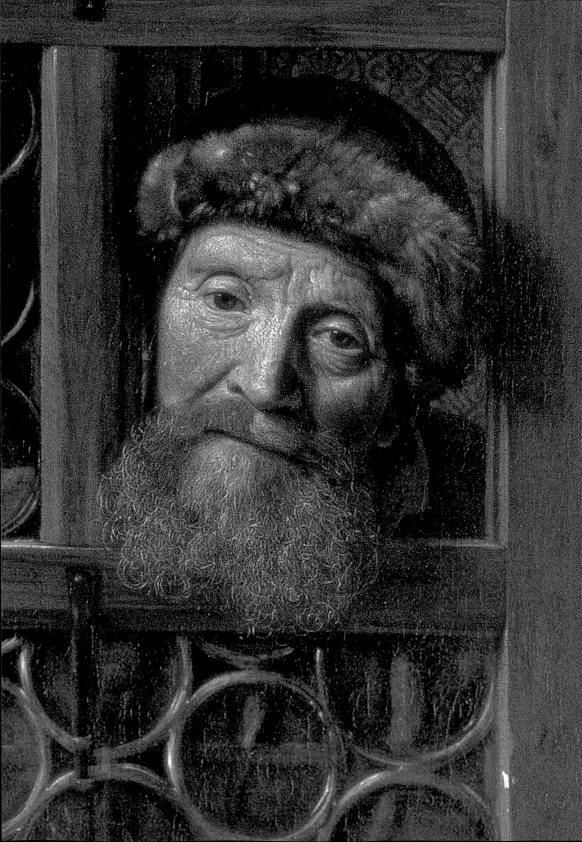

Suffering monopolizes awareness

First comes pain, physical or mental. Then suffering, which is the impact of pain on awareness.

Suffering is the accessible aspect of pain. When pain itself is too intense, be it mental or physical, it must be eased by medical treatment. The psychological work will come only afterward. But it must come, must be done, or the suffering will endlessly recur.

For suffering naturally tends to become the gravitational center of our awareness, the dark sun around which everything else turns. The space of our awareness seems to shrink around it, and there's no room left for anything but pain. This is suffering— pain that takes up all the space and prevents all other sensations and thoughts from becoming established. All our mind's energy is absorbed and consumed by pain. Nothing else exists.

Pains of the body

Many of our physical pains should not be faced with the power of our mind alone. In this area we should shed every scrap of pride, and painkillers will often save our dignity. Otherwise we become suffering animals. But afterward? What can help us have less fear of pain and stop locking ourselves away in suffering? Can mindfulness help us? Perhaps . . . Perhaps it can help us prepare ourselves better, without waiting for pain to come, working in advance on its more moderate forms.

It has long been shown that experienced practitioners of Zen meditation (which is similar to mindfulness) have improved resistance to pain. It has recently been discovered that this capacity correlates to changes in their brains and that this neuroplasticity is linked to the numbers of hours that they meditate. One possible explanation is that, because it demands long periods of stillness, with the cramps and other sensations of discomfort that go with it, meditation offers regular, calm opportunities to manage small painful sensations.

I still remember the first time it happened to me, when I was meditating one morning, at a time when my life was rather complicated—nothing terrible, just a bit of everyday adversity, tiredness and stress. I sat down on my bench and, within ten seconds, got a cramp in the sole of my left foot. Agonizing. My first reaction was to move and ease it, open my eyes, change position, even to stop meditating—after all, I had so many other things to do, I didn't want it to hurt me as well, on that day of all days. . . . Luckily I was saved by my patients. We'd talked about this kind of thing the day before, in the mindfulness group at the hospital. So I strove to contemplate the thought "Move—in fact just stop and go back to work," and to see it as just a thought, not a necessity. I strove to notice it and distance myself from it, as a product of my mind. I made the choice not to go along with it and not to move, disobeying my reflexes ("If you feel something painful, get out of the way!"). So, before

moving (which I really wanted to do), I decided to take time to examine the pain of the cramp. Where was it, exactly? Was it stable or did it change? What was it pushing me to do? And of course, a minute later it was gone. Dissolved.

Although I knew that this did happen, I was rather surprised. I was amazed that it had worked, here and now, in my own body. Here is yet another example of the incredible difference in kind between *knowledge* and *experience*, two worlds that are further apart than you might think. True, it doesn't always work. Sometimes you really do have to change position, or stop meditating altogether if the pain is too much. Meditating is not a form of masochism. But when you can go through suffering just by accepting that it's there, not reacting with agitation but just with awareness, it's always really strengthening! It's the meeting of theory, intentions, speeches and reality. Even we professionals never tire of discovering and rediscovering this. It makes us feel that we're on the right track, safe and consistent—it works! I know, I've done it.

Another reason why meditation is an aid in facing suffering is that calming the mind has an analgesic effect. Our brain spends its time filtering minor pain messages so that they don't endlessly importune our awareness. This is known as "descending neural control." When we are depressed or stressed, our brain does this work less well and we have more pain everywhere. If we are at peace, the same amount of pain causes us

less suffering. But here again, we can't just turn on this sense of peace at will, we have to work at it, long before the pain arrives. We can't wait for the aircraft's engines to fail before we start weaving our parachute.

Does meditation also work on mental pain?

Pains of the mind

When we cling to our painful thoughts by ruminating on them, we solidify them. We give them substance and importance. We ruminate on our ills and turn them into monsters.

Rumination is the solidification of our mind's chatter. Without meaning to, we turn an ordinary reaction into suffering. In our moments of depression and anxiety, what makes us suffer, above and beyond what is happening to us, are our thoughts and beliefs, which we cling to and turn into rigid certainties.

Having given birth to these little monsters, we then bond with them like mothers.

A negative thought doesn't hurt us if it comes and goes. It becomes painful if it fills our awareness, takes root and stops all other thoughts from taking root or even existing. In the long term, if we let ruminations wander through our mind too long, they create paths and runnels down which our distress can flow, and which are then adopted by other streams of distress, leading to "impulses to feel bad," which are hard to control, discouraging and exhausting.

Deal with everyday adversity

But how can we stop our mind from being drawn toward these magnetic sufferings? The only solution is paradoxical—we must make more space for suffering, in order to loosen its grip.

Mindfulness has an effect on our everyday distress and suffering. It enables us to prevent our worries—which are usually preoccupying uncertainties—from turning into certainties, and our emotions—which are movements—from becoming chronic and hardening into passions. It allows us to prevent them from solidifying. It helps us not to remain blocked and stuck in a painful state of mind.

When we are in the grip of pain, we imprison ourselves, sometimes without realizing we have done so. Before freeing ourselves from our prison, we must be able to see its bars. So the first step is to notice the reality of distress, accepting it and perceiving it in our

body, observing the thoughts associated with it and the impulses to which they give rise. We don't like the fact that this distress is there, because it hurts and frightens us. The little voice of mindfulness tells us, "Stay with it. Don't be afraid to stay with this in your awareness. True or false isn't the issue. The issue is whether you are able to make room for suffering, ideas, feelings, states of mind of this kind without collapsing, panicking or hurting yourself." Exactly the same thing is expressed in a Chinese proverb: "You can't prevent the birds of sadness from flying over your heads, but don't let them nest in your hair."

So as not to be consenting victims of rumination, we must first accept that it is there. After this, we must not allow it to take up all our mental space by itself. We must welcome other guests into our mind (already preoccupied with ruminations), such as awareness of our breathing, sounds, our body and awareness of all the other thoughts that come, go and return. To allow our thoughts to be fluid and to flow freely again, we must give them space and more space. We should not try to drive out our ruminations or to have none at all. On the contrary, we must allow them to be there, but not alone, diluting them in a much bigger container so that their relative importance is reduced.

And then we must breathe. In the jargon of mindfulness instructors, we talk about "breathing with" and "breathing within." It's not very elegant terminology, but it is clear. "Breathing with" means

we keep observing our suffering while gently (and patiently, because suffering always comes back to the center) placing our breath at the center of our awareness. "Breathing within" means we observe the effect of our breath on our suffering, as though our breath was passing through it. By practicing often on small sufferings, small adversities, we may perhaps have more to draw on when we have greater difficulties to face. Perhaps . . .

The impermanence of suffering

At the end of all this is the awareness and practice of impermanence, which reminds us that nothing lasts, everything passes, and that excessive clinging to reality is a mistake that increases suffering. It also whispers advice to us that goes far beyond the "management" of suffering. We all have a mad hope that things we are attached to—people we love and things we own—will always remain with us. In the same way, when we suffer, we feel an equally mad despair—we are convinced that the suffering to which we are chained will also always be with us.

But nothing lasts. Neither our pleasures nor our pains. Neither attachments nor prisons. We may understand this, but we need to experience it, in mindfulness, observing the objects we are attached to. We need to have a different relationship to them—it's not a matter of giving them up, but of fluidity. Things that are transitory are not necessarily unimportant and it would be mad to pretend to detach ourselves from

everything. We simply need to observe that it's possible to pass through everything and notice everything without getting too attached, and to go on living and savoring things.

LESSON 15

One great source of mental suffering is a lack of awareness—not realizing that we distort reality and then clinging with all our might and main to this distorted reality. Psychotherapists speak of "distortions" and "ruminations," knowing that we must first quickly realize that our mind has fallen into a trap and then free ourselves from these traps. Sometimes, although we know that they are doing us harm, we can't detach ourselves from our obsessions and ruminations. The message of mindfulness is simple: if it's too hard, I give up trying to expel these painful thoughts by an effort of will and expand the scope of my awareness instead to take in all the rest of my experience of the present moment. I don't give up all my mental space to my obsessions and ruminations, instead I dilute them in the largest possible container—my infinitely expanded awareness.

LET GO

t's not her naked body that strikes us. It's not the surprising detail of the white sheet carefully laid over the stony ground, from which small green shoots are starting to emerge. It isn't the delicate, awkward, touching position of her feet. No, the things that strike us are her eyes, her impassive, seemingly triumphant face and her expression of calm certainty. Her eyes suggest that we look at her left hand and the olive branch she holds as if it were some trophy, evidence or argument—the olive branch that speaks of peace and hope.

Behind her is a kind of shattered mountain. If we look more closely we see that it's not a rocky mass but ruined buildings. And the walls running across the fields are tombs with straggly crosses.

Puvis de Chavannes painted this picture a year after the Franco-Prussian war of 1870, and the humiliation of

Hope, Pierre Puvis de Chavannes (*1824–1898*)
1870–1871, oil on canvas, 70.5 x 82 cm, Musée d'Orsay, Paris

France in a lightning defeat that led to the fall of the Second Empire. He called it *Hope* and was widely criticized for it. But what would the critics have preferred? That instead of an olive branch she had brandished a gun, and launched another war? Or a spade, to rebuild everything?

Forever indifferent to any idea of revenge and indifferent for now to any idea of action, with no force but her thin, naked body, the girl is taking time, becoming aware. She is feeling and passing on an awareness of past disasters and of the new times that are coming.

And then we see that, in front of her right hand resting gently on the white sheet, an oak seedling is already growing up toward the sky.

Where then is my pain?
I have no more pain.
It's only a murmur
at the edge of the sun.

PAUL FORT, "SONG TO THE DAWN"

Don't fight

When we have problems, we try to solve them. We try to eradicate, change or escape them. But with some problems our efforts don't work, for example if the problems are within us (our thoughts or feelings) or inaccessible (some types of adversity) or do not yet exist (our anticipation). So sometimes we need to stop fighting and abandon our habitual responses to pain, accepting that they make some situations more complicated and even more confused and painful.

When you walk through shallow water on a sandy beach you raise little clouds of sand. If you want the water around your feet to be clear again, you know there's no point trying to flatten the clouds of sand with your hands or feet. You will simply stir up more of them. The harder you try, the more sandy clouds there will be and the less calm the water. The only solution is to stop, allow the clouds of sand to be there and to wait for them to sink. Then you will be able to see clear water around your feet again. The clouds of sand are painful life experiences. If we want to see more clearly, mindfulness recommends that we take a moment to stop wanting to control them and just watch them sink to the bottom.

The philosopher Simone Weil wrote, "We have to try to cure our faults by attention and not by will. . . . Inward supplication is the only reasonable way, for it avoids stiffening muscles that have nothing to do with the matter. What could be more stupid than to tighten

up our muscles and set our jaws about virtue, or poetry, or the solution of a problem?"

But then, if it's not action but attention that's the solution, where should we direct our attention when we're stuck or caught like people in the middle of a

river? If we don't try to move forward and we can't go back, what can we do?

Stop and breathe

When faced with suffering and distress, we should start by breathing.

In general, we prefer to ruminate or torment ourselves. It seems more honorable and more realistic or effective when we are caught up in our concerns. Sometime later, of course, we realize it was absurd to have been so worried. But by then it's too late, and we generally prefer to forget and think about something else. Until the next time and the next problem, when the same process will start all over again.

Mindfulness suggests that we breathe and work on our suffering while it's here, not trying to suppress or solve it at that moment, not even trying to feel good. Just staying there with our breathing, like an old friend who doesn't yet know what to advise us, but who is with us and stays beside us. The presence of this friend is perhaps, ultimately, more important than the problem itself.

Our mindful breathing will gradually have a soothing effect. While rumination solidifies our unpleasant thoughts and feelings, mindfulness softens them, as a candle flame softens wax. Let's carry our unpleasant experiences to the light and warmth of mindfulness. Even if we feel vulnerable or weak, even if we know that this won't change the problem. Why try to *start* by changing the problem?

Why try to *start* by changing the problem? Why not begin sometimes by changing our reaction to the problem?

Why not begin sometimes by changing our reaction to the problem?

The present moment as a refuge

When we stop to breathe, even if everything around us is painful, we may feel as though we are in a refuge. Like a ship sheltered in a bay or a harbor during a storm. It all rages on, but we are in a place of shelter. It's imperfect and transitory, but it is shelter all the same. When we breathe we understand that we are alive, that nothing is more important and the rest can wait, for a few moments at least.

Taking refuge in the present moment doesn't mean we have solved the problem, or found a solution. No, the problems go on and the solution won't suddenly appear with our breath—always assuming there is a solution. The problems go on, but we have found a safe place from which to observe them, without being forced to fight for fear of being submerged or drowned.

Breathing in adversity means placing our mind in a refuge. Not in order to flee reality or to act, but so

that we can choose to see more clearly, make space for calm and give our intelligence a chance. Whatever I do, whatever I think, the problem is here. It's already here. But I am alive, I am present. And I'm going to go on being so, as best I can. Breathe. Soon something will change. I must just accept not knowing what or when.

LESSON 16

What does it mean to let go? It means not trying to escape reality by means of distraction ("Think about something else!") or persuasion ("Just relax, it will all be fine"). We already know how to do these things, and sometimes they work, but not always. No, letting go is something else that's also very useful—it means just being where we are, being present, with a particular mental attitude. Not trying to be in control or find a solution. Just being there and trusting in what will come. Not naïvely, but with curiosity, remaining attentive. Like a swimmer who stops swimming for a moment to be carried by the current. This is not passivity, but presence.

STAY PRESENT TO THE WORLD

Nothing unusual is happening. The farmer is plowing, the shepherd is guarding his flock and staring at the crows, the fisherman is waiting for a fish to bite. The ships are sailing. In the distance is a bay, with islands and harbors. Everything is where it should be. Except . . . What is that shepherd watching? There's a man up there with wings. It's Dedalus, alone in the sky. He is looking toward the right of the picture, as though searching for something, or someone.

Dedalus is still flying—he has been careful not to fly too close to the sun. He has just noticed that his son Icarus is no longer at his side. He is looking for him in the sky. This is the false normality of moments before a disaster. We look with him—there's nothing in the sky but the

The Fall of Icarus, Pieter Brueghel the Elder (entourage or circle of) (*c. 1525–1569*)
c. 1590–1595, oil on wood, 63 x 80 cm, Museum Van Buuren, Brussels

dazzling light of the burning sun. Lower down perhaps? Yes, there, you can see poor Icarus's leg still sticking out of the water.

He is going to die, drowned or broken by his fall. For him it's all over. But for all the other human beings life goes on, it follows its course. And this is what Breughel is saying to us: everything goes on as before. No one is interested in the death of Icarus—not the farmer, not the shepherd, nor even the fisherman, although he is close by when it happens. And once this death becomes known, what difference will it make? Unfortunate people die every day, everywhere. And the Earth keeps on turning just the same.

Is this a scandal? No. It's just an event that makes a few waves. And perhaps it's a good thing that the Earth keeps on turning. What use would it be if, every time disaster struck us, the world collapsed as well?

Develop a mind that is vast like space, where experiences both pleasant and unpleasant can appear and disappear without conflict, struggle or harm. Rest in a mind like vast sky.

BUDDHA, *MAJJHIMA NIKAYA*

Do not lose the world

Pain takes up all the space. It invades our awareness, or else it's we who close up around it, particularly when we are in mourning, or missing something or someone. The pain is linked to what we have lost, and not suffering anymore means losing even more. So, when we close up around our pain, we are at once seeking an "analgesic position" as the doctors say, and anchoring ourselves to what we have left. But reacting like this, closing up on ourselves, our pain and our memories, puts us in danger. We have come out of the world. The philosopher Simone Weil speaks of the "degree of pain on reaching which we lose the world." How, after a little time has passed, can we make our way back to the world? How can we sincerely accept our suffering, since we can't and sometimes don't want to drive it out, while still staying in contact with the world around us?

To stop great pain from pulling us out of life, we must work on small pains, staying in the world through the discouragements and dejection of everyday life. Working on small sadnesses to try to prepare as best we can for the shattering effects of larger ones.

Start by expanding our awareness

We must ensure that our suffering is not alone, with all our attention focused and closed in on it. We must enable other things to exist in our awareness as well, making space for our breathing, our bodily sensations and the sounds around us. We must expand the

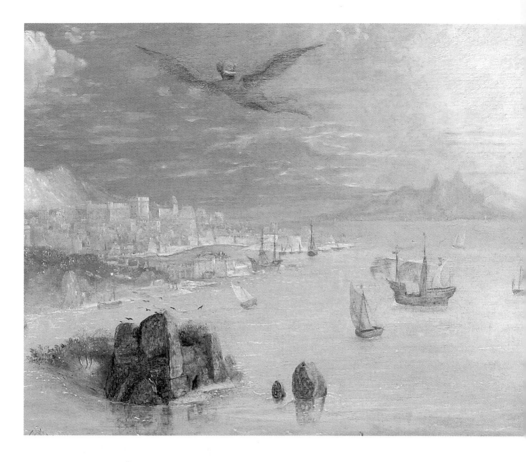

container, not allowing the pain to take up all the space in our awareness. We must invite into us all the bits of life that are within our reach.

Then we should observe our thoughts, which are also focused on the pain. We should sit down, close our eyes, breathe and take time to see where our distress is sending us—to what forms of withdrawal, what isolation. We must keep breathing, feeling, existing. We must not block out our breathing in order not to block out the life around our sadness and suffering.

Do some kinds of sadness pass all by themselves? Undoubtedly yes. Perhaps equally quickly with or without this approach. But suffering digested in mindfulness will not leave the same furrow for subsequent suffering to follow. It will be no more than an unpleasant memory, rather than a small time bomb.

Consolation

The solitude of suffering is real and absolute—no one can suffer in our stead, no one can relieve us of any of our pain. So is there nothing that can be done to help us? Is there no possible form of consolation?

There is, but the problem is that we can't or don't want to hear it. Generally speaking, we don't listen to consolation, because we're convinced in advance that it's useless. It's true that it's useless if what we want is for everything to be the way it was before, for the problem to disappear—for the accident never to have happened and the dead to return. If what we want is reparation, consolation is useless. But if we can reach an understanding that reparation is impossible, that there's no solution for our suffering, if we can then also manage to listen to consolation it will teach us something else—that alongside our suffering there is still a life that is open to us.

If we make these efforts, we will discover that behind consolation lies compassion. Compassion is not medication for disaster, just a lifeline, an encouragement to go on living in spite of everything. But it

expands our awareness to the fact that there is also love and affection around us. It gives us a humble message—sometimes those around us are powerless and all they can give us is their presence. They are powerless to repair the situation, but present to remind us to go on living and being human—don't become an animal of pain, don't destroy yourself, don't harden yourself, don't quit the world. Stay alive. . . .

Will we go on weeping?

Will Dedalus abandon the idea of flying forever? Or will he go on flying, thinking of his son? Will he go on admiring the movement of the sun and clouds, the beauty of the earth and sea, the delicate pattern of the foam on the shore? Or will he choose to remain prostrate and weeping forever?

Fly, Dedalus! Fly and keep the memory of your son flying with you. Go on living and flying. What else can you do? And when you fly, don't try to block or repress your sorrow. Just open your mind to the endless sky. Welcome into yourself, intensely, the beauty slipping by beneath your wings. Be present with all your might to what the world has to show you. Don't be afraid to keep your sorrow with you as you fly. See what your son saw. Sense what he sensed. Breathe for him, smile for him, love the world for him.

This life that goes on, that offends you by continuing, will be your salvation. Everything is here. Icarus is here. And he flies with you.

LESSON 17

When we are suffering very badly, when we are very unhappy, we cut ourselves off from the world. We no longer find it interesting. It seems indifferent, almost offensive to us. Yet, in its own way, it can help or save us. The more we suffer the more we must make sure we remain in contact with everything around us. Suffering is always increased and prolonged by separation and distance, by withdrawal into ourselves. I must train myself so that when I feel unhappy I still remain sensitive to the beauty of the world. Even if it doesn't ease my pain, even if it doesn't help me straightaway. There will come a time when everything will shift and it will save me.

MOVE FORWARD, EVEN WHEN YOU ARE HURT

f we do no more than glance at it in passing, this painting shows a gentle country scene—a girl is lying in the grass calmly looking at a group of buildings at the top of a hill.

But if we stop for a moment, we sense that something is wrong. The reddish grass recalls the plains of Hell while the house is too far away and too dark. And there's something odd about the girl too. We look more closely, trying to see what the problem is. Her position is not quite right, not quite normal for someone just sitting back and enjoying the landscape without a care in the world. It's more like the position of someone dragging themselves along the ground. And her arms are too thin, her elbow is that of an invalid, she has red blotches on her

Christina's World, Andrew Wyeth (1917–2009)
1948, tempera on panel, 81.9 x 121.3 cm, Museum of Modern Art, New York

skin and her left hand that grips the grass is swollen and distorted. What's going on? What are we being shown? The story behind this painting is that the young woman depicted is paralyzed and ill. She's not daydreaming at all, but crawling home because she refuses to use crutches or a wheelchair. And she's not a young woman either; in fact she is fifty-four. The painter, Wyeth, knew her very well—she was Christina Olson, one of his neighbors in the village of Cushing, Maine.

So now we understand the reasons for our discomfort a little better. The painting is showing us a secret distress, a veiled loneliness and sorrow, which we must try to grasp as best we can. And it raises the question of a choice we often face in our lives: should we go forward or back? Will we go forward, crawling, even when we are hurt?

We should seek neither to escape suffering
nor to suffer less,
but to remain untainted by suffering.

SIMONE WEIL, *GRAVITY AND GRACE*

Hidden wounds

There are visible, physical wounds and there are wounds of the spirit, weaknesses that stem from past deficits or tragedies. They are invisible, but etched into our minds and flesh. Whether we are aware of them, or whether they lie dormant, these weaknesses turn us into people living between two worlds—apparent normality and secret abnormality.

For a long time we dreamed these wounds and weaknesses didn't exist. Then we dreamed they might gradually be erased by life, love and time. But today, despite our efforts and the passing years, we have to accept that they are still here, and will be for a long time, perhaps forever.

So we learn to forget them, to stop thinking about them, to act as if they weren't there. And most of the time it works. But every now and then, when we are stressed or sad, when life treats us roughly, everything comes flooding back. The skeletons come out of the closet.

The old demons awake

When we have suffered from depression, anxiety or other emotional disturbances, the scars lie dormant. In reality we are in remission, because time has passed and we've changed, or because life has gotten easier. But if it gets harder again, the fault lines reopen and with them comes the feeling that we could easily collapse, just like that, in front of everyone. These moments when we are once again feeling sucked into

everything that isn't right with us are crossroads. We can still take action and deal with them, much more than we think.

This is why the practices of mindfulness meditation have been imported into psychotherapy—to help with what's called "relapse prevention." Traditional therapies like psychoanalysis, which probe the roots of our suffering, are not enough. Newer treatments, such as cognitive and behavioural therapies, do a little better, but remain imperfect. So it has been suggested that work on mindfulness be added to these other approaches and solutions. So far it seems like a good idea—relapses seem more widely spaced and less acute among people who practice mindfulness.

Being aware that thoughts of distress can be reactivated by the pressures and jolts of everyday life enables us not to obey them—or at least not completely—and to make a real choice to hear and ignore them, to go forward and make an effort, even if they are telling us it's pointless. Even if they are telling us we haven't got the strength, even if they scream at us to stop making the effort, we must not obey them.

Mindfulness helps us not to allow ourselves to be intimidated by these orders that come from deep within us. By meditating when we feel bad, we place our discouragement and worry in a space of mindfulness. But by also meditating when we don't feel so bad, we deal with the little waves in order to cope better with the storms. . . .

Step by step, moment by moment

We mustn't just stand there doing nothing. Mindfulness has allies and one of them is action. We can take the same approach we would adopt on an exhausting march, when the temptation to stop is overwhelming and stopping is impossible. We put our head down and keep going, one step at a time. We can act and go forward even when we can't be sure there's any point. Even when nothing is certain, we can still disobey the orders to be powerless that come at us in waves. We can feel these old reflexes rising up from the past and trying to control us. And still we keep going.

The crucial thing is not to cut ourselves off from the world. We must look up and take in everything around us. We can watch the thoughts of discouragement and of collapse as they assail us, but we mustn't stay shut away inside ourselves with them. We must open wide our mental doors and windows to the world around us.

Keep going to the refuge over there

In a little while Christina will get home. She will sit on the doorstep and watch the sinking sun, as she does every evening. In spite of everything she will feel happy to be alive. She will feel happy despite her paralysis and fatigue, her sore hands and the unutterable sadness that almost always colors her life. The painter will ask her if he can paint another portrait of her, sitting there on the doorstep in the

light and she will say yes. She will look at the sun once more. She will feel the calming of her breathing. She will sigh, and then she will smile. And the moment will be perfect.

LESSON 18

Sometimes we feel so bad that we have to take refuge in action alone, becoming beasts again, just maintaining our efforts to survive without thinking. Because we know that thinking when we are unhappy can generate even more unhappiness and blindness. So we just actively do something. We need to have an overall sense of what's good or necessary for us, in other words to have thought a bit about it beforehand! Then we can carry out some action, in total humility. We do this because we know that it will help us survive. We go for a walk, garden, tidy up, make something or work. We don't do this in order to escape or feel better but because there's nothing else we can do and if we do nothing we'll go under. It's not fun, and it doesn't make us feel good, but sometimes life is like that.

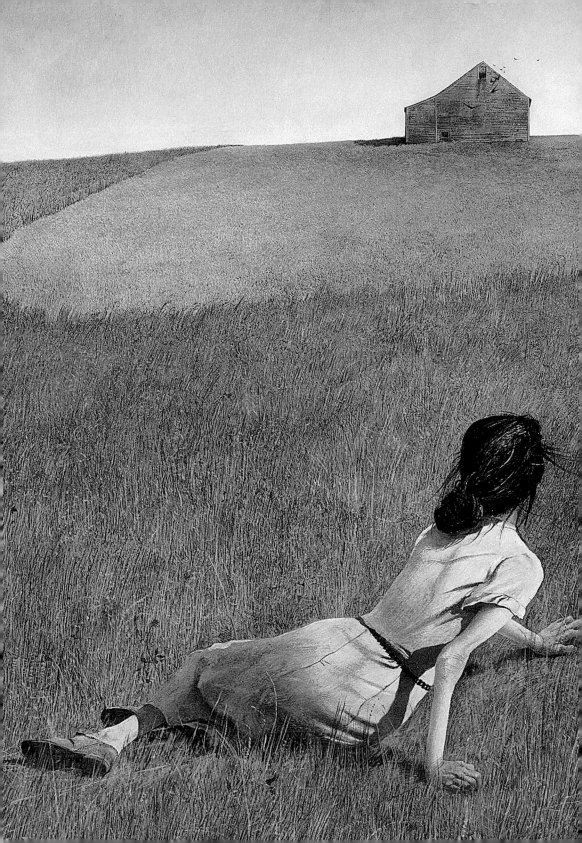

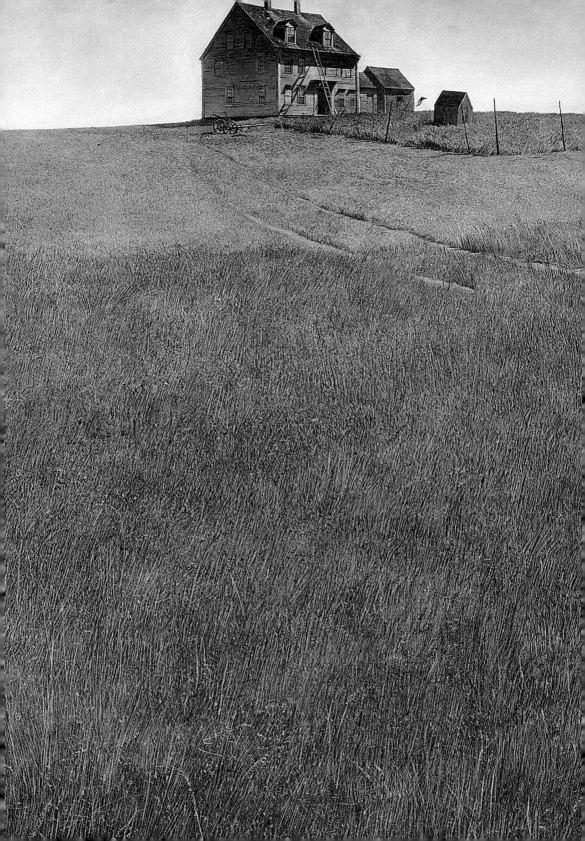

ACCEPT
MYSTERY

The wall of cell 7 in the north dormitory of the Convent of San Marco in Florence is covered by a strange and magnificent fresco. It's one of the most astounding, disturbing artworks I have ever looked at.

In an unreal, dreamlike atmosphere of supernatural peace, the blindfolded Christ is assaulted—not by actual figures, but by blows and spitting, slaps and a stick. His extraordinary, abstract assailants are suspended in midair. What's more, Jesus is being assaulted, but he is also sitting on a throne in majesty, holding a reed scepter and the orb of a worldly king. How can he be at once humiliated and triumphant?

His mother, Mary, and Saint Dominic sit at his feet. Mary has withdrawn into deep, thoughtful sadness. Saint Dominic is reading. They both seem to be elsewhere,

Christ Mocked in the Presence of the Virgin and Saint Dominic,
Fra Angelico (c. 1400–1455)
1438, fresco, 187 x 151 cm, Convent of San Marco, Florence

but they are not indifferent to Jesus. If Mary is worried, it's over him. And the book Saint Dominic is reading is almost certainly his life as told in the gospels. So they are not indifferent to Jesus himself, yet they seem indifferent to his ordeals. They haven't abandoned him; they are still connected to him—Mary in thought, Saint Dominic by his reading. Yet they are not trying to help him or offer him any sympathy. Why not?

In the bright light of the fresco there's not much for our logic to grasp. Everything seems obscure to us. For the time being all we can do is settle for understanding nothing. But doesn't the same thing often happen in our own lives too? Even if we would like to persuade ourselves to the contrary. . . .

Truth is a land
without paths.

TIZIANO TERZANI, *Le Grand Voyage de la Vie*

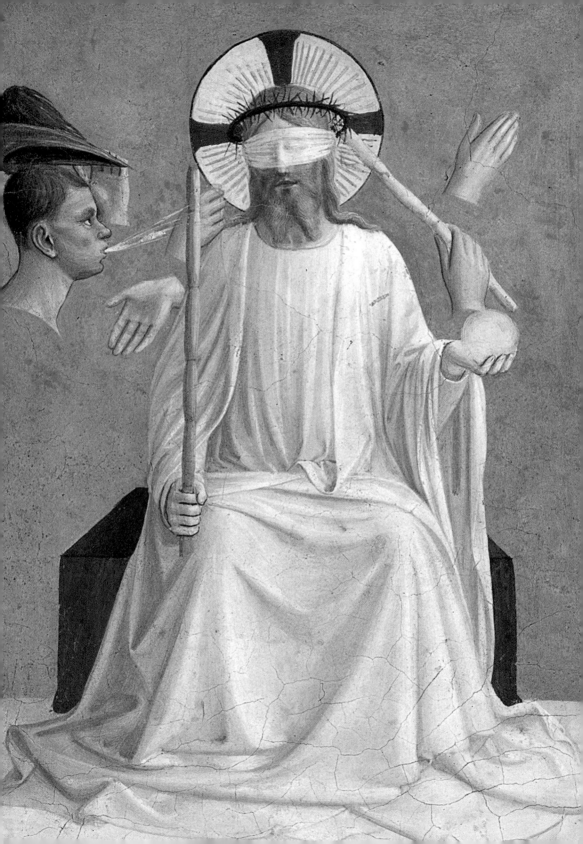

Mistreated, blinded and human

Like Jesus in the fresco, we may be overwhelmed and suffocated, overcome by the violence of things that happen to us out of the blue. Despair is a blinding experience—it shrinks our field of vision so that our horizons are confined to the deluge of adversity that has befallen us. It is also dehumanizing. We become animals of pain, mad with suffering. All connection to the world is impossible. Great pain isolates, blocks and freezes. It leads to inner drowning on top of outer tragedy, and lives that are shattered both within and outside us.

So it's important for us to strive with all our might to remain sensitive human beings. We must hang on to our humanity and the things around us that awaken it, such as nature and beauty. We must go on opening our mind to things other than our suffering—not to conceal adversity, or to forget it, but just so that it doesn't take over as absolute ruler of our mind and life. Take this passage from a book by Austrian psychiatrist Viktor Frankl, who survived the Dachau concentration camp: "One evening, when we were already resting on the floor of our hut, dead tired, soup bowls in hand, a fellow prisoner rushed in and asked us to run out to the assembly grounds and see the wonderful sunset." This kind of behavior is not escapism or a psychological defense mechanism to escape horror; it is an act of awareness and supreme intelligence. At a time when they are surrounded by an ocean of death, these human beings turn their minds to what is also beautiful in the

world. They are powerless, lost and confused, but they do not abandon their humanity.

"Three negative capabilities"

In a famous letter to his brothers of December 22, 1817, the poet John Keats encourages them to cultivate what he calls "negative capabilities." He sees these as a form of maturity and psychological completion: "Several things dove-tailed in my mind, and at once it struck me what quality went to form a Man of Achievement, especially in Literature, and which Shakespeare possessed so enormously—I mean Negative Capability, that is, when a man is capable of being in uncertainties, mysteries, doubts, without any irritable reaching after fact and reason."

Uncertainty, mystery and doubt. How can we cultivate the ability to tolerate a loss of control and reference points without immediately trying to find something concrete and rational to hold on to?

We must learn to live with uncertainty. Uncertainty is a source of anxiety. All forms of anxiety can be ultimately brought down to an intolerance of uncertainty. When we are tormented by thoughts of the future and death it's because these are our two greatest uncertainties. We try to limit uncertainty in our lives by insuring ourselves and taking precautions, or by endlessly checking and rechecking, running the risk that all these attempts at protection will wear us out and build barricades around our lives. We try to fill our mind with certainties, but without really reassuring

ourselves. We know perfectly well, deep down, that all our efforts are pointless, that our incantations and supplications are no more than feeble gestures. For the truth is that there are insoluble problems in our lives and we have to accept them. We must accept them, but not contract around them. We must keep living and going forward, carrying their insolubility with us.

We must learn to live with doubt, with not knowing what to think or do. We must abandon the need to cling to judgment or actions, to ready-made thoughts that are ineffective but reassuring. We must give up making choices, or at least give up the idea that our

choices are bound to be the right ones. Often we have no option but to say to ourselves, "I don't know, I can't know, I can only doubt." But this doubt should not stop us choosing and acting when we must. Nor should it stop us living with new doubts, replacing "What should I do?" with "Did I do right?"

We must learn to live with mystery and incomprehensible things that are beyond our grasp. This seems a little easier, because we sense that mystery is beyond our grasp, so we accept it better. But mystery is not chaos. Some logic, solution or meaning may lie behind it. So we ask ourselves questions, endlessly. In the mystery of misfortune, suffering or injustice, often there are only questions—why?—and no answers. It's better that way. Because, when answers do come, they are dangerous. They are false, hard certainties in the sea of misfortune: "I'm cursed, incurable and there's no way out." It's better to have no answer at all than an answer like that. And perhaps better, in some kinds of distress, to learn not to ask questions in the heat of suffering.

It is better, perhaps, to breathe and open our mind.

The present moment and chaos

What can we do in adversity, we who are incapable of Christ-like certainties? We must seek refuge in the present moment and train ourselves to make room for feelings of not knowing, not being able or not understanding. We must observe how uncomfortable these feelings are, how they try to suffocate us with waves of distress and chaotic impulses: "Stir yourself,

do something, don't just sit there." We must cultivate and develop our tolerance for this experience, just as, when we listen to a friend, at certain points we need simply to listen, without feeling duty-bound to solve the person's problems for them. We must free ourselves from the pressure to find a solution, which may make us unable to listen properly. We must do the same when we examine our own worries. Let's gently assess the state we are in, here and now, before tensing up around the need to take control—there will be time enough for that.

It's also important to see the acceptance of not understanding or being in control as a liberation and a positive choice, rather than as a defeat or a duty. We must truly abandon the idea of being in control, rather than doing it regretfully, through gritted teeth. We must abandon it mind and body, body and soul, rather than abandoning it with our body (resigning ourselves to doing nothing) while moaning in our mind. We should feel how soothing it is to give up.

It's important to note that this attitude should almost certainly not always be adopted immediately. Sometimes—often—we should start by looking for solutions. But if we can't find any, or the problem starts all over again despite them, it means the exit route lies elsewhere.

My intelligence and reason enable me to illuminate and understand my problems and help me find solutions. But sometimes their light is not enough. On the contrary, it may imprison me and hide other

avenues from me. When it shines, the sun gives us the feeling that it shows us all that there is to see on earth. But when it goes down, night falls and the sky is spangled with stars, we suddenly realize there were other things to see, which the sunlight had hidden from us.

LESSON 19

No one likes to find themselves in a position of weakness or powerlessness. But we don't always have a choice. So can we prepare ourselves for this situation? Perhaps. By regularly practicing mindfulness exercises we will be regularly confronted with a mind that does its own thing and with emotions and sensations that hurt us. But by deciding just to go on with the exercise regardless, despite discomfort and disorder, we will acquire the precious ability to tolerate the feeling of being overwhelmed and out of control. Learning just to be present despite suffering is not a form of masochism. It doesn't mean we like to suffer, it just means accepting that these things can happen in our lives, and being a little bit prepared.

SEE
HAPPINESS
GENTLY EMERGE

t's like a promise quietly emerging on the horizon, a marvel taking shape before our eyes as we approach from the lagoon. The city gradually rising out of nowhere is Venice. Soon we will be there. Soon we will step onto its fragile ground; we will explore it all, astounded by its magnificent, dying beauty. The sun seems to welcome us, in one last burst of light and heat, turning the sky above the lagoon a wonderful, golden yellow.

The moon has already risen above the horizon, on the left of the picture, bringing with it a little freshness and the blue of night, which will soon darken. The sun and its light will have gone by the time we land. So we find this moment troubling, it makes us shiver. The day and the splendors of dusk have brought us so much happiness. What will happen now, if the sun withdraws?

Approach to Venice, Joseph Mallord William Turner (1775–1851)
1844, oil on canvas, 62 x 94 cm, National Gallery of Art, Washington, DC, Andrew W. Mellon Collection

We enter paradise every second—either
that or we leave it.

CHRISTIAN BOBIN

Happiness as an act of awareness

Everything starts with well-being. Having a full stomach, being calm, warm and free from danger—this situation is already perfect. It's marvelous to feel like that. This elementary well-being is common to all animals, indeed to all living beings, including humans. It's possible to look no further. But this is not really happiness, because what we call happiness is much more.

If we are aware of these moments of well-being, if we say to ourselves, "I'm lucky to feel like this, it's marvelous—a grace," then something else happens. Well-being transcends into happiness. If I open my mind and savor the good things that happen to me with all my awareness, making myself present, then the impact on me of this moment will be infinitely stronger. It will go beyond the simple state of satisfied physical and psychic needs. It will be able to fulfill, and calm my aspirations and metaphysical itches for meaning, belonging, love, peace and eternity. . . .

There is no happiness without awareness. Or at best there is only retrospective happiness, as in the famous words of the writer Raymond Radiguet: "Happiness, I knew you only by the sound you made as you left." Without awareness of the present, we will long for past moments of happiness that we didn't know how to feel at the time, the stillborn happiness that we did not bring to life with our awareness. This is what happens to us when life harries us, when we have so many things to do that we don't take time to open our

eyes to all the possibilities for happiness that cross our path. It also happens when we are sad or worried. We stop living in the present and our mind remains trapped in uncertainty about the future or regrets over the past. When this happens we can only hope or weep for happiness. We can no longer feel it.

Mindfulness can help us to savor more intensely the many *potential sources* of happiness that our days offer us. If we go about with our mind on something else (our projects, our thoughts, our worries), we will see and feel nothing. If we regularly open our mind and awareness to everything around us, not looking for those sources, we will see them. Without seeking it out, we will be touched by the grace of things. And we will often be happy, if only in snatches. These fleeting moments will be parentheses of happiness in our everyday lives—slight, brief, imperfect and incomplete, but multiple, changing, alive and constantly renewed. Our lives will have a dusting of happiness—they will be happy in snatches. In other words, they will be happy lives.

Awareness and subtle happiness

Awareness, which makes happiness arise within us, will also generate a fear of losing happiness. When we are happy we are clearly aware that soon we will cease to be so. We are happy only intermittently, and throughout our lives happiness will appear and disappear. The important thing is not to try to hold on to it, worrying or distressing ourselves with the idea that it will soon

be gone, but to enjoy it, accepting its eclipses and remaining alert to its return, however fleeting its visits.

Pessimists and worriers find this hard to bear and sometimes prefer not to give themselves up to happiness and all that's good in their lives because they know it won't last. They're right, it won't. But so what? Surely it's precisely because happiness will leave us that we should enjoy it. Our choice is between being happy and then not being happy, or never allowing ourselves to be happy at all. Between soaking up happiness and remaining tensely miserable as a way of defending ourselves against both happiness and its loss. I know which I prefer.

Science shows us that when we are aware that we're experiencing happy moments for the last time, the happiness they bring us isn't diminished, it's just more complex. It becomes more dense, serious and lucid. But it is still happiness all the same—a subtle form of happiness that has incorporated the tragedy of life, without denying it, but without allowing it to be distressing. Is happiness a tragic idea? Of course!

Happiness within unhappiness

Why should happiness always be a matter of being carefree or unaware? Why should it not also be found where it's needed, on the tragic side of life? In mindfulness we train ourselves to notice everything, pains and pleasures alike, and to bear and make space for complicated, subtle, disconcerting experiences. This is what real life is like—not the life we might dream

of, but the one we inhabit, the one we cannot escape and which teaches us that our dreams are only dreams. And it's a good thing that we can't avoid it, because it's this life that is most interesting.

When we encounter happiness, again, meditation doesn't lead us out of the world, but helps us integrate this happiness more fully into our reality. And in reality, happiness and unhappiness almost always go hand in hand, as light goes with shadow. This is no doubt why Albert Camus wrote, "I no longer wish to be happy, just to be aware." We're going to try to reconcile the two and cultivate our awareness, not in order to replace happiness, but to illuminate it, make it denser and bring it into the world. This is what André Comte-Sponville called *wisdom*—"the maximum happiness with the maximum lucidity."

I remember an excellent study showing that people in mourning for a dead partner who were able to smile as they talked about the person they had lost ("It's so painful to have lost him, but I'm so happy to have known him") were also those who felt the best two years later, because they had the ability not to allow happiness to be overwhelmed by sadness. They were able to understand that life consists of everything together, and that unhappiness does not invalidate past happiness, or take it away from us. The happiness we have experienced remains ours forever. We are perfectly entitled to weep and smile at the same time—we do so because we accept the world, and decide to love it with all our might.

In times of sadness we can stop and accept tiny snippets of happiness, even if they are brief, sad in themselves, incomplete, imperfect and fragmentary.

In the same way, with all our might we love Venice, a city that has been dying for centuries and will soon disappear beneath the waves.

In the same way, with all our might we love Etty Hillesum, imprisoned in the sinister Westerbork transit camp, a stop on the route to the death camps, who wrote, "Living and dying, sorrow and joy, the blisters on my feet and the jasmine behind the house; the persecution, the unspeakable horrors; it is all as one in me, and I accept it all as one mighty whole."

In the same way, with all our might we love Eugenia Ginzburg, waiting to be sentenced to death or the gulag in the Soviet courtroom to which she had been dragged without the slightest idea of the charges laid against her, who looked outside all the same: "Outside the windows there were some large, dark-green trees: their leaves were rustling and I was moved by the cool, mysterious sound. I could not remember having heard it before. It was strangely touching—why had I never noticed it?"

This is the height of mindfulness and humanity, more perhaps than we are capable of ourselves, but which can still inspire us. In times of sadness we can stop and accept tiny snippets of happiness, even if they are brief, sad in themselves, incomplete, imperfect and fragmentary. We should expect only immediate, fleeting comfort—as soon as we go back to living and thinking, unhappiness may return. But a little later on we will do it again. And so on, endlessly, again and again.

We will keep on making our misfortune breathe alongside everything that resembles life—in other words, happiness.

LESSON 20

When it comes to happiness, mindfulness teaches us simply that, as happiness is inseparable from unhappiness and life is bound to confront us with tragedy and disarray, it's better not to dream of perfect, permanent happiness, but to learn to savor it in snippets. We can make space for it despite our troubles and worries, among them rather than waiting for them to pass and for our problems to be solved (the day we feel that all our problems have been solved will never come, particularly if we are of a worried or melancholic disposition). We must preserve our little moments of happiness, even in adversity—in fact particularly in adversity. It is then that they are at their most touching, magnificent and indispensable.

4.

OPENING
AND
AWAKENING:
THE GREATEST
OF JOURNEYS

Today your body is truer than your soul;
tomorrow your soul will be
truer than your body.

Gustave Thibon, *L'Illusion féconde*

WORK

What we see does not exist, or at least not like that. The painting looks like an architectural "exploded view," where the walls have been removed the better to show us the insides of a huge gothic building, revealing its secrets and structure. Our eye passes over three concentric layers.

In the center sits Saint Jerome at his worktable. It's not his sainthood that is emphasized here, so much as his erudition, through all the manuscripts that surround him, and his humanity, through touching details—the shoes he has taken off to go up the stairs, the cat asleep beside him. Around him the shell of the large building is reminiscent of a monastery. It's an austere structure that protects him from distractions, but lets life in all the same. Look to the right, where a lion prowls in the shadows of

St. Jerome in His Study, Antonello da Messina (*c.* 1430–*c.* 1479)
c. 1475, oil on wood, 45.7 x 36.2 cm, National Gallery, London

the cloister. The story goes that Saint Jerome healed an injured lion, which followed him to his monastery, where it was adopted.

The surrounding third layer is open to the world. In the foreground of the painting, near the viewer, is a huge portico and, on its steps, a partridge and a peacock. In the background, large windows reveal rural landscapes and a distant city, while others are open to the sky and birds in flight.

Here we have inner work and the outside world, with a reassuring but open framework between the two. This is what appeals to me in this painting, what I like to make it say and how I choose to interpret it to serve my purpose. Looking at this Saint Jerome I think of the practice of mindfulness, with its regularly alternating moments of meditative withdrawal into ourselves and openness to the world. And its regular, patient work. . . .

Everything starts in necessity
and must finish in liberty.

MAURICE ZUNDEL, *VIE, MORT, RÉSURRECTION*

Training the mind

Where do we get this amazing tendency to believe that we are the masters of our minds? And to think our capacities for attention and awareness are obviously established, without the need to work at them?

We seem to imagine that, unlike our muscles, our brain has no need of training and can't be developed. Yet we accept that our body needs training. We know that physical exercise develops our breathing and muscles, that appropriate food is good for our health, and so on. But we are less convinced, or perhaps less well informed, about the similar needs of our mind. Training the mind and mental exercise are also extremely important. At the intellectual level, they help us build up our capacities for thinking and concentration; at the emotional level, they help us block our spontaneous tendencies to become stressed, downcast, angry and all the other lapses to which our everyday lives make us vulnerable. Our psychic abilities generally obey the rules of learning—the more we practice, the more progress we make.

In fact this is what happens anyway. The more often we get irritated, the better we get at irritation; the more we practice pessimism or negativism, the more expert we become at discouraging others and ourselves; the more often we get stressed, the greater stress champions we become.

So if we want to go in a different direction, we need to work at it. We accept this when it comes to learning

Not that we should expect to be able to put our mind on a leash and exert total control over it, but we can reestablish a balance of power. Being able to concentrate or to calm down at times when we need to.

to speak another language, ski or play a musical instrument, but it's harder for us to practice serenity and concentration. For example, some people say to themselves, "Why should I have to practice every day? Isn't life enough in itself? Aren't my intentions and resolutions enough in themselves?"

Well no, these things are not enough. If we settle for vague intentions to change, we will never use our mind properly, we will always remain complaining, consenting victims of the same old reflexes, we will go on producing the same curtailed thoughts and the same uncontrollable emotions. This is why, among other forms of mind training, the practice of mindfulness is particularly useful for everyone, and particularly necessary for those who have noticed that their mind evades and disobeys them. Not that we should expect to be able to put our mind on a leash and exert total control over it, but we can reestablish a balance of power. Being able to concentrate or to

calm down, for example, at times when we need to, doesn't seem to me to be a particularly ambitious or excessive goal. But are we always able to do these things?

Practicing mind training routinely every day is good for our health—it's like fitness training for our awareness.

It's also a way of cleaning our mind of social pollution. Regularly practiced, it's like everyday maintenance for our inner self. And as with maintenance in the real world, if we keep up with it, it doesn't show—we soon get used to feeling good. It's when we don't do it that it shows! Or rather, that we feel it. No doubt the main "risk" associated with mindfulness practice is that we start to depend on it and, if we stop doing it, we

gradually start to feel less emotionally stable and more mentally volatile.

Mind training is also a form of asceticism. The simplicity of the practice conceals its difficulty and the need for regularity. And it is also a school for patience—we can never hope for an immediate effect—and humility—practice doesn't offer any guarantees. So after our initial enthusiasm and the feeling—and sometimes tangible proof—that the regular exercises have reduced our psychic fragility, we are ready to believe that we've made progress, which is doubtless true, and that this progress is stable and established. This is not true. We will relapse. "Practitioners' relapses" are the rule. They are just part of the way things go—after successes and enthusiasm you will be brought down, for example, by a fit of rage, depression or worry. Is this humiliating? Only if you saw your progress in meditation as a source of pride and particularly if you made a fuss about it, telling people you were meditating, advocating it as a panacea for all ills and going around ostentatiously displaying your calm detachment. Is it disappointing? Only if you were previously excessively happy about what you had achieved, even in secret, even just a little. Is it funny? Yes, if you accepted right from the start that this was bound to happen one day, and if, when it happens, you receive your disappointment calmly, in mindfulness. You knew it would happen, you had accepted it. All it means is that you must keep on meditating, again and again.

Exercises and practice

I use the word *exercises* to refer to mindfulness practice when we don't need it, when our life is going along normally, without any particular suffering. There are three levels of exercise: formal practices, short practices, and life itself, in mindfulness.

Formal practices are long exercises done regularly—every day when we start learning to meditate and then weekly or monthly. In some of these we learn to review our whole body, without trying to change its sensations, but just trying to be aware of it, gently and respectfully. This is what we call—to use a medical metaphor—a body scan. In other formal practices we connect to the movements of our breathing, or to sounds and the incessant movement of our thoughts. This is what we call mindfulness of sounds and thoughts. There are many others. We can teach ourselves to do these exercises using audio materials, which enable us to find out what to do and to start weighing up its effects and difficulties. But a time will come when we need advice and answers to our questions, and at that point we need to attend sessions run by a mindfulness instructor. The term *instructor* signifies that this is not a form of therapy (although people suffering from psychic troubles may be advised to practice mindfulness), but rather a learning process, a set of instructions that people can then go away and use on their own.

Short practices (a few minutes) are intended to be carried out several times a day. They may take the form of "simple" moments of awareness at set times—such

as at the hourly sounding of the bell in some Buddhist monasteries, or between seeing two patients for a doctor, or in between two separate tasks for someone working in an office, when we are waiting for something and so on. Or they may be carried out at times of distress and suffering. Instead of ignoring our feelings or following our usual cycles of rumination, we strive to be aware of them and make room for them while keeping our mind as open as possible to our experience of the present moment. This is what is called a *breathing space*. If we are finding things difficult, whenever possible we should stop and allow the unpleasantness we feel inside us to be there, while being present to the movement of our breathing for three minutes. Then we go back to our activities, benefiting from the mindfulness that we have activated for those few minutes.

Living in awareness

The widest exercise space is life itself. Life in mindfulness, to which we have referred throughout this book, simply means passing through the greatest possible number of moments with our mind wide open. It means regularly stopping for a few seconds, minutes or more, to feel, intensely and wordlessly, whatever is happening inside and outside ourselves. It is a kind of calm chewing and digestion of our own lives (instead of absent-mindedly gulping down all the moments that make up our life). We may do this at what we think of as ordinary moments, or during important events. Ordinary moments would be while

we are eating, walking, drinking, working, chatting, waiting or doing nothing. Important events might be ceremonies (such as birthdays, weddings or funerals, where mindfulness helps us register their importance, rather than giving way to the distraction and chatter of our mind) or moments when we are in the presence of nature or beauty.

A resource and an observation post

If we regularly practice these exercises, mindfulness will be a great inner resource in times of suffering. First as a refuge—the present moment offers a refuge from distress of all kinds. Then as a means of stabilizing our attention—it gives us back our ability to notice, observe and then decide what to do.

But it's also an observation post. When we don't fully understand, when our will is not enough, when we can no longer control our agitation or our disordered thoughts, mindfulness practice can help us to avoid living any old way, passing by the things that matter.

The same is true for well-being. As we have seen, mindfulness is a way of elevating well-being into happiness. It can help us increase our lucidity in moments of happiness and let them mark us more deeply. It can help us bodily absorb these moments when they come to us, and get the measure of them, understanding and accepting that they will not last. We do this not to make ourselves sad or detached, but to enjoy and love our happiness all the more,

and to understand its beauty. Mindfulness helps us understand that our moments of happiness are like flowers—we should breathe in their scent and then let them go. They are not like gold pieces, to be stored and accumulated. They are magnificent, fragile flowers, as ephemeral as our own lives. With each exercise, mindfulness simply helps us live and be aware that we are alive, and that being alive is wonderful.

LESSON 21

People with long experience of meditating recommend that we should start and end our days with a few moments of mindfulness. On opening my eyes in the morning and closing them at night, I should pay attention to my experience of the present moment (my body, my breath, the chatter of my thoughts, the course of my emotions). They also recommend including regular spaces of mindfulness in the course of our days (when we are waiting or between activities). Lastly, if we want to go further, they recommend that we practice more deeply once a week, for half an hour or an hour. This is easier to do in a group, with an experienced instructor.

CONTEMPLATE

The traveler has reached the summit after a day of climbing.

He set off very early this morning, well before dawn. On the long walk to the peak he had not a care in the world. The sound made by his boots, the rhythm of his heartbeat and breathing, the regular flow of his footsteps and the metallic clunk of his stick on the rock all filled his mind with soothing input from his senses. Sometimes he was assailed by thoughts of the difficulties before him, but when this happened he opened his awareness more widely to the present moment—his walking, the sounds around him and now too the first colors of dawn. Then the thoughts would disappear, only to return and then vanish again, no

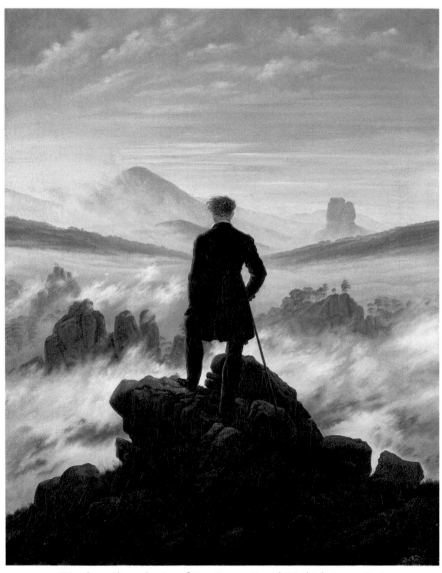

Wanderer Above the Sea of Fog, Caspar David Friedrich (1774–1840)
c. 1818, oil on canvas, 94.8 x 74.8 cm, Kunsthalle, Hamburg

more solid than feathers in the wind or the mist on the mountainside.

Now he has reached the summit. At first he savored his victory—"I'm here! I've done it!" Victory should always be savored. It's a way of freeing ourselves more quickly of childish emotions around success, such as pride and contentment. So we might as well feel our victory completely, allowing the slightly nauseating sweetness to spread through us, before we turn our attention to something more interesting, beyond all that. Then the mountain takes hold of us again and we are overwhelmed by this world that receives us with such hospitality. We open our mind to all that is here—the splendid horizon, the purity of the air, the silent presence of the summits and the sound of the wind.

With each inbreath the traveler feels that he is taking the whole mountain into himself. With each outbreath his body and soul dissolve into it. He feels endlessly, boundlessly good and totally, absolutely at home.

> He who reaches his goal
> has missed all the rest.
> ZEN SAYING

Engagement and detachment

Mindfulness helps us engage in actions that matter to us. Then it helps us detach ourselves from enslavement to the result of these actions.

This is a difference reflected in Ancient Greek by the terms *telos* and *skopos*, the end and the goal. When an archer learns to shoot, the *telos* is to shoot well and the *skopos* is to hit the target. Those things that are within my reach and depend only on me are *telos*. The *skopos* also depends on other things, such as a breath of wind that blows the arrow off course, or a sudden noise that makes me jump at the last moment.

In the same way, the practice of mindfulness requires that I regularly sit in silence with my eyes closed and concentrate on noticing and observing my experience. On the other hand, I have to accept that the results of my doing this may vary considerably from one day to the next. Only one thing is certain: the more often and the longer I sit in this way, the more often I will hit my target.

This way of engaging in action, in mindfulness, enables us to contemplate the absolute in our everyday lives. Detachment follows engagement—it's like a slow, patient walk toward an absolute that's beyond us. But the sequence of engagement followed by detachment isn't easy.

At first, when we are working on detachment, we pretend. We aren't really detached. We just want to save ourselves from suffering, calling on detachment to help us not suffer from the failures, abandonment

and torments of our everyday lives. But we are not so keen on being detached from success, praise and glory! So we cheat and fake it with false modesty, false indifference and false distance. Meanwhile deep down we are secretly licking our lips and puffing ourselves up. But if we force ourselves, if we practice regularly, if, after every success, we sit down and allow it to settle rather than getting carried away with self-celebration, if, after every failure, we do the same instead of being irritated and beating ourselves up, gradually strange things happen inside us. We are less shaken by the froth of action. We notice that there's something more interesting beyond immediate events. It starts looking like the mountain top.

Mindfulness, spirituality and mysticism

We can have a spiritual life that is unconnected to religious practice. Spirituality is just the most elevated part of our psychic life, in which we contemplate the absolute and things that are beyond our grasp. It is that aspect of us that goes beyond our ego, remaining open to everything, and therefore also to the unknown. Without this it's too easy to be open only to all that is known, logical, acceptable and predictable. Spirituality is not about running away from things that are beyond our grasp but, on the contrary, exposing ourselves to them in mindfulness. And what things are beyond our grasp? Infinity, eternity and the absolute—those three head-spinners. . . .

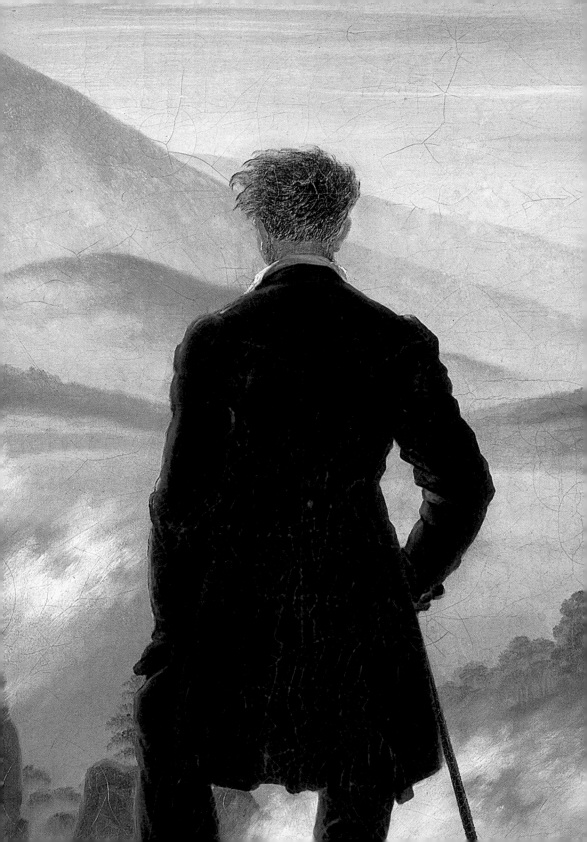

Spirituality precisely requires the two-fold movement we have just described—engagement and detachment. We practice and keep moving forward until we reach the point where we let it all go, shed the baggage of our efforts and goals and abandon ourselves to contemplation.

In the Catholic faith, contemplation means "looking long and with admiration," an attitude that requires "peace and purity of heart." In its secular version, it is calm and nonjudgment—in other words, mindfulness.

For the philosopher André Comte-Sponville, the contemplative attitude leads to the practice of mysticism: "The mystic is he who sees reality face to face. He is no longer separated from reality by speech

(a state I call silence), or lack (which I call plenitude), or time (which I call eternity), or by himself (which I call simplicity, the *anatta* of the Buddhists). He no longer lacks even God himself. He experiences the absolute here and now."

Mindfulness is thus clearly a secular mysticism. It is a search beyond explanations and words, which seeks enlightenment and an absolute that we are ready to do nothing with, since there's nothing to do but be imbued by them, allowing ourselves to be bathed and illuminated by them. This can sometimes lead us to a kind of light, calm, silent ecstasy. Sometimes—and sometimes not. . . .

Ecstasy, enstasy and moments of grace

Ecstasy means leaving the self behind and fusing with something larger. It may be a divine or sometimes a carnal revelation, giving access to a world that is not that of ordinary life, in a state of awareness that is not that of ordinary life. It is a fall, leap or detour—because we usually return from it—into transcendence and the absolute.

Enstasy means falling into the self, and discovering that everything is there. It is the sweetness that rises from within, the calm that has been allowed to emerge from within. Suddenly we feel a volcanic eruption of serenity. It's always overwhelming to feel this self-generated peace and to observe how *enstatic* calm connects us to the world rather than cutting us off from it. We allow ourselves to be transformed, rather

than always, endlessly striving to transform what is around us.

These experiences happen during moments of grace, which occur when we're least expecting them. Such moments of grace can spring only from mindfulness and a real presence to reality, as in the moment described by the poet Christian Bobin: "I was peeling a red apple from the garden when I suddenly understood that life would only ever give me a series of wonderfully insoluble problems. With that thought an ocean of profound peace entered my heart."

No need to climb mountains, a red apple is enough.

LESSON 22

Mindfulness does not recommend that we cut ourselves off from the world or retreat to a hermitage, nor that we adopt the posture of a sage who is distanced from everything. It simply encourages us to savor our lives more fully. We should go on making choices and pursuing goals, but without merging with them, without excessively clinging to success or perfection. Is it possible to be at once engaged on the surface and deeply detached? We must do our best, in awareness and presence, but without seeing our effort, which depends on us, as less important than the final result, which does not depend on us alone. Rather than beating our own records or—worse—other people's, we should be interested only in the doing itself. We must stop thinking of our lives in terms of victories and defeats, seeing them instead in terms of the experiences that make us who we are.

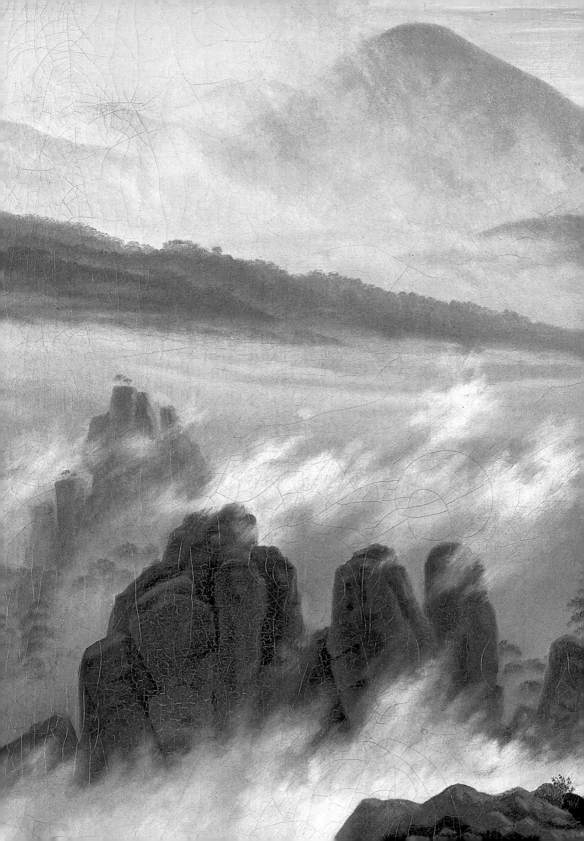

LOVE

S imeon has long understood that this child is the Messiah and he is going to turn everything on earth upside-down. Simeon knows this, and he also knows that this means infinite suffering for Jesus, and therefore also for his mother. He tells Mary, "A sword will pierce your soul." Simeon has sensed that Jesus is bringing the revolution of love to the Earth. No one before him has so proclaimed and revealed that God is love, and that God wants love to reign supreme. The old gods dominated human minds solely by force and by fear. Jesus heralds a God of infinite mercy, and the coming of his reign. This message of the absolute primacy of love will change the world in the West. Meanwhile, in the East, Buddha's message stresses the importance of compassion and the way to reduce suffering for all of humanity.

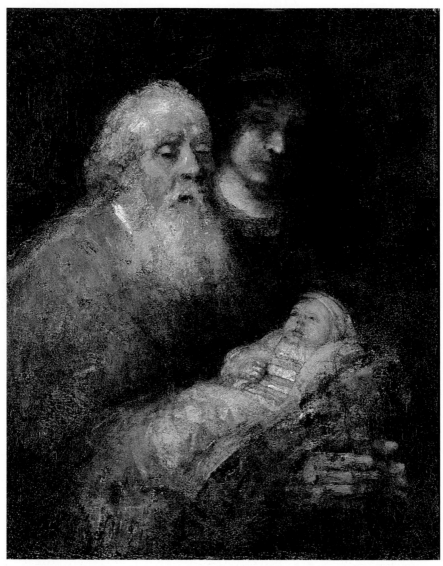

Simeon in the Temple, Harmensz Van Rijn, known as Rembrandt (1606–1669)
1669, oil on canvas, 98.5 x 79.5 cm, Nationalmuseum, Stockholm

So when Simeon takes Jesus in his arms for the presentation at the temple, he has a terrible longing to hug and kiss him, to thank him for all he brings with him and to comfort and support him in facing all the sufferings that await him. But he doesn't do these things, not at once. He must not touch the baby with his bare hands, but with the prayer shawl of the Jews, which Catholic liturgy has transmuted into the humeral veil in which the priest carries the ciborium containing Christ in the Eucharist. Simeon is deeply moved to see, at last, the Messiah for whom he has waited so long and he utters the *Nunc dimittis* sung at compline: "Master, now you are dismissing your servant in peace, according to your word; for my eyes have seen your salvation." Simeon can die happy. Now love will flow across the world. . . .

I shall not speak, I shall think of nothing:
But infinite love will rise up in my soul.

ARTHUR RIMBAUD, "SENSATION"

The milk of human kindness

The words are Shakespeare's, in *Macbeth*. They are spoken by Lady Macbeth, sorry to see this sign of humanity in her husband when she's urging him to murder Duncan, the king of Scotland. "Yet do I fear thy nature; / It is too full o' th' milk of human kindness / To catch the nearest way." She makes "the milk of human kindness" sound like a criticism, something to be regretted. It won't stop the murder, but it does cause Macbeth to be plagued by guilt and it drives his wife mad. The phrase reminds us that we are creatures of connection and love. Without emotional nourishment we are in danger—we can't grow or blossom. Without love we live badly, hardening or sinking into madness or illness.

Life can make us forget or neglect this dimension of our humanity. The practice of mindfulness suggests that we reconnect with it very regularly, to help us reduce our sufferings and those of other human beings, and also to understand and more often use its formidable power.

I am surrounded by a crowd of human beings who have loved and helped me, smiled at me and given me things, who continue to do so now, and will do so tomorrow. Gratitude is being aware of this debt, rejoicing in it and expressing our joy. When I regularly turn my awareness to this thought, to the point where I feel it physically, I am meditating in gratitude. There are three fundamental aspects to gratitude: recognizing its importance; then pausing for a moment to do more

than just think about it, allowing it to spread through our body as an emotion and not only as a thought; lastly, of course, expressing it to those who have loved and helped us. Thought, emotion, behavior.

More broadly still, it is crucial to be aware of the extreme, absolute importance of love in all its forms (altruism, affection, tenderness, kindness, compassion, generosity and more). It is crucial to meditate on this love, and put it into action every day. This philanthropy in action is known to Christians as *charity* and to Buddhists as *altruistic love*. But the two are clearly the same. They are both about understanding, making space for and practicing the love of our fellows.

Meditation and connections of love

Buddhist teaching, which has codified these attitudes extensively, generally approaches work on altruistic love through four meditation practices, which must of course be understood as moments of preparation for putting this love into practice.

First are the meditations of benevolent love, which involve thinking of the people we love and truly loving them, here and now. This doesn't mean simply telling ourselves that we love them, but allowing the love (or affection, or liking) that we feel for them to grow and manifest itself physically within us. It's a bit like what you may feel watching a sleeping child or a person you love who doesn't know they're being watched. It is a love that involves your whole body, not just your thoughts. In these meditations we try to make the

> What is asked of us is not just
> to have compassionate *thoughts*
> or *intentions*, but literally
> compassionate *emotions*.

greatest possible space in our awareness for this love, and to turn our body into its most sensitive soundbox.

Then come the compassion meditations, in which we turn our mind to the sufferings that those close to us may feel, or have felt. We become aware of them, make space for them within ourselves, and with all our heart we desire them to diminish or cease. Here again, this wish must go beyond a simple, quick or superficial thought. We must make and feel it entirely. What is asked of us is not just to have compassionate *thoughts* or *intentions*, but literally compassionate *emotions*. When we hear of someone's suffering, sickness or death, what do we do? Do we stop, for a few minutes at least? Do we take the time to allow the person's image to be established within us, and for thoughts of affection and compassion to take up all the space within us? The regular practice of this is compassion meditation.

Meditations of altruistic joy meanwhile seek to gradually establish the habit of sincerely rejoicing in the happiness of others. We rejoice altruistically at

things that are good for others, such as when we see children laughing and playing, even if they aren't ours, or lovers kissing or people talking to and helping each other. Of course, life is full of other things too—we also come across instances of violence and meanness. But what meditations of altruistic joy precisely help us to remember is that, alongside such violence and meanness, there are also sweetness, happiness and love. We know this, but feeling it in mindfulness will give our knowledge more weight.

Lastly, equanimity meditations recommend that we train ourselves to remain capable of wishing the good of all human beings, even those who are distant from or unknown to us, even those we don't like or who have done us wrong. We must work on feeling benevolence and compassion for these people, and altruistic joy at their happiness. The meaning and belief underlying these meditations is that suffering is the source of most problematic behavior. If human beings are happy, if they suffer less, they will make others suffer less as well.

What seeds do we want to see growing in ourselves?

We can become champions of indifference, envy, jealousy, selfishness and resentment. All it takes is for us not to make any effort when these emotions rise up within us, allowing them to take over and to fill our awareness all by themselves. We can then be sure that they will return, always stronger and more present. Allowing them free rein will not calm them; it will

simply root them more firmly in our mind. When it comes to dealing with destabilizing emotions, catharsis and outpourings don't work.

On the other hand, we can become champions of altruism, benevolence, compassion and equanimity as long as we make space within ourselves for these feelings, regularly and deeply. Now we've said all there is to say about this.

LESSON 23

Mindfulness gives substance to our good intentions. Our bursts of affection for those close to us and for others less close will gain from being expressed in words and deeds, but they can also be felt in the privacy of our inner selves. We should make time on a regular basis to feel love, sympathy, gratitude and all the emotions of affection that life normally enables us to feel. This is not a matter of vague intentions ("I must tell him") or hasty thoughts ("I'm lucky, I'm loved"), but prolonged, repeated meditation rooted in our body. It will change everything.

EXPERIENCE THE EXPANSION AND DISSOLUTION OF THE SELF

What's going on here? What is the left hand doing, hidden under the table? Where did that strange stone come from, all pockmarked with little craters? Did it fall from the moon? And why is the right hand in that odd, spider-like position, apparently caught in the middle of a movement that has lost all its meaning? And what about the head of this elegantly dressed man, dissolving in a ball of yellow light, as though suddenly irradiated by a mental sun? It looks like the light falling on the window of the meditating philosopher in the painting by Rembrandt at the very beginning of this book—remember? This is the portrait of a disappearance—or a transformation. The suit

The Pleasure Principle, René Magritte (1898–1967)
1937, oil on canvas, 79 x 63.5 cm, ex–Edward James Foundation, Sussex

(life that takes itself seriously) will soon be emptied of its substance.

Soon this mind boiling like a sun (mysterious life) will overflow the material body and leave it behind. It is the portrait of an incandescence of the mind. Soon there'll be nothing left on the canvas but light. And then nothing at all.

My diffuse and vaporous life becomes as
the frost leaves and spiculae radiant
as gems on the weeds & stubble in
a winter morning. . . .
By simplicity—commonly called poverty—
my life is concentrated—and so becomes
organized or a cosmos which before was inorganic
and lumpish.

HENRY DAVID THOREAU, *JOURNAL* (FEBRUARY 1857)

Expansion

Mindfulness is like an expansion of the self. We absorb everything around us; we are imbued with, and become it. Like a circle expanding to encircle everything, we are at the center of this universe, but it's not bounded or limited. All its borders are porous.

We started the session all tight and tense, curled up around our thoughts, irritations and desolations. And then we stopped, sat down, and closed our eyes. Yet still it went on—the ringing in our ears, the annoyance, confusion, disorder and fragmentation. What on earth is the point of all this? Shall I stop? No, I'm going to keep going. I'm going to keep going, without touching anything. I'm not going to alter my experience, not going to block anything out or cut myself off from anything. What's here may have—almost certainly has—good reasons for being here. I'm just going to open up, expand, and invite other guests into my awareness. I won't remain alone with this chaos, but I will allow it to be there. I breathe. I notice that I'm breathing.

There are sounds around me—awareness. I become aware of all the parts of my body. I start to feel the grip loosen. I even feel that I can open my eyes and contemplate the wall, objects and sky. I can absorb everything that's happening. All the chaos, annoyance and disagreeable feelings are still there, along with the external problems that created them. But now they look smaller, less important. I keep on taking in everything around me. Like some gargantuan psychic ogre, I gently devour the world and reality. The more

I take in, the more serene I feel. But after a while, I'm struck by a question: who's devouring whom?

Dissolution

In mindfulness we often have a recurring sense that the boundaries between ourselves and the external world have broken down. We feel our self fuse with our surroundings and our surroundings diffusing into our self. Is it scary? Not at all. On the contrary, it's pleasant and reassuring. It enables us to discover the degree to which withdrawing into our ego is ultimately a bad solution.

Remember, we referred to the way that Buddhism, in its poetic, image-laden language, talks of the "seeing deeply" that gives us access to the true nature of phenomena, and in particular their *emptiness*. We are like rainbows. To exist is to dissolve and be reconstituted.

I often have this feeling on sunny days when we hold meditation sessions in the gardens of the Sainte-Anne Hospital. There we are at the end of a shift, barefoot in the grass, surrounded by the distant rumble of Paris that reaches us over the walls, and so bathed in a world of sensation that we seem to swim in it, losing all sense of our boundaries. It's a feeling of expansion and very intense presence, but without ego, as though we have left ourselves behind without needing to die. In fact, far from feeling dead, we feel ultra-alive. Far from disappearing, we feel as though we are spreading everywhere through the world around us. Our presence

> "Abandon everything, abandon all that you know, abandon, abandon, abandon. And don't be afraid to be left with nothing for, in the end, it is this nothing that sustains you . . ."

becomes something that needs no explanation. We feel "like the wheat that grows or the rain that falls," as Etty Hillesum wrote.

Liberation

When this happens we feel light almost to the point of nonexistence—but not quite. This is not really a movement toward nonexistence, but toward a form of belonging that is beyond our grasp.

I'm reminded of the noosphere of the Christian theologian Teilhard de Chardin. Just as we use the term *atmosphere* for the layer of air and *biosphere* for the layer of plant and animal life that surround our mineral planet, so we can speak of a *noosphere* (from the Greek *noos*, meaning intelligence, mind, thought) to refer to the invisible, intangible but very real layer of all human thoughts, which together make up *extelligence*, a dizzying fusion of all our individual intelligences.

I'm reminded of the metaphor of the raft and the crossing. After we have crossed the river, lake or ocean, our precious raft becomes a useless hindrance when

we continue our journey across the continent on which we have landed. We have to leave it behind, without regret. We still have the most important things.

I'm reminded of the words of the sage who said, "Abandon everything, abandon all that you know, abandon, abandon, abandon. And don't be afraid to be left with nothing for, in the end, it is this nothing that sustains you. . . ."

I'm reminded of what Simone Weil wrote: "Let the soul of a man take the whole universe for its body. Identify with the universe itself." I think of this difference between eternity and immortality. We know that immortality is not for us. But when we fully live in the present moment, we feel that we are in eternity. It exists and we feel it.

LESSON 24

Mindfulness breaks down pointless boundaries, such as those that separate us from the rest of the world. We're always afraid of disappearing and dissolving, but when we have done it dozens of times, we necessarily fear it less. Meditating in mindfulness means connecting with the world, so strongly that the distinctions between what is self and what is not self become absurd, pointless and burdensome. We must gently prepare to return to where we came from, just as waves quickly dissolve in the ocean. Then there are no more boundaries. Only connections.

TAKING FLIGHT
UNIVERSAL
AWARENESS

Goodbye, and remember,
faith is finer than God.

Claude Nougaro, "Plume d'ange"

View of Haarlem with Bleaching Grounds,
Jacob Isaackszoon Van Ruysdael *(c. 1628–1682)*
c. 1670, oil on canvas, 62.5 x 55.2 cm, Kunsthaus, Zurich

I was there.

I was there, Jacob Van Ruysdael, in the autumn of 1670, when you were painting that picture. I was there with you, on the hill of Het Kopje, in the dunes near Bloemendaal to the northwest of Haarlem. I was there and, like you, I was fascinated by the wonderful sky that seemed to be putting on a show for us, playing us a symphony. I was there in the hairs of your brush, in the droplets of water in the clouds, the breath of the wind and the fibers of the strips of linen laid out to bleach in the fields below. I was there in your breath and the smoke from your pipe, in the fly that bothered you—remember?—flying around your head.

I am here.

I am here in this book, in the paper and the printed letters. I am here and the thoughts passing through your mind contain a little bit of me, you can feel it. You are here too, in my mind, at the moment you read my words. When you look up and catch sight of the sky, or when you go to your window to look out at it, I will be looking at the same sky. We breathe the same air. We are on the same planet. Tonight, or the night after, the same stars will shine above our heads. We are part of the same universe.

Be aware of all this.

Be aware.

Now.

And

Forever.

SOME USEFUL BOOKS

TO FIND OUT MORE ABOUT MEDITATION AND MINDFULNESS

POETIC WRITINGS

Kabat-Zinn, J., *Wherever You Go, There You Are: Mindfulness Meditation in Everyday Life*, Hyperion Books, 1994.

Kabat-Zinn, J., *Coming to Our Senses: Healing Ourselves and the World Through Mindfulness,* Hyperion Books, 2005.

Kabat-Zinn, J., *Arriving at Your Own Door: 108 Lessons in Mindfulness,* Hyperion Books, 2007.

BUDDHIST WRITINGS

Gunaratana, Bhante Henepola, *Mindfulness in Plain English,* Wisdom Publications, 1994.

Khyentse Rinpoche, D., and Patrul Rinpoche, *The Heart Treasure of the Enlightened Ones* (Foreword by the Dalai Lama), Shambhala, 1993.

Mingyur Rinpoche, Y., and Eric Swanson, *The Joy of Living,* Harmony Books, 2007.

Nhat Hanh, T., *The Miracle of Mindfulness: An Introduction to the Practice of Meditation*, trans. Mobi Ho, Rider Books, 1991.

Ricard, M., *The Art of Meditation*, Atlantic Books, 2010, available as a Kindle e-book.

Ricard, M., *On the Path to Enlightenment: Heart Advice from the Great Tibetan Masters*, trans. Charles Hastings, Shambhala, 2013.

SCIENTIFIC WRITINGS

Hanson, R., with Rick Mendius, *Buddha's Brain: The Practical Neuroscience of Happiness, Love, and Wisdom,* New Harbinger, 2009.

Kabat-Zinn, J., and R. Davidson with Zara Houshmand, *The Mind's Own Physician: A Scientific Dialogue with the Dalai Lama on the Healing Power of Meditation*, New Harbinger, 2012.

PSYCHOTHERAPEUTIC WRITINGS

Fehmi, L., and J. Robbins, *The Open-Focus Brain: Harnessing the Power of Attention to Heal Mind and Body,* Trumpeter, 2007.

Kabat-Zinn, J., *Full Catastrophe Living*, Bantam, revised edition, 2013.

Segal, Z., et al., *Mindfulness-Based Cognitive Therapy for Depression: A New Approach to Preventing Relapse*, Guilford Press, second edition, 2013.

Williams, M., et al., *The Mindful Way Through Depression: Freeing Yourself from Chronic Unhappiness*, Guilford Press, 2007.

Williams, M., and Danny Penman, *Mindfulness: A Practical Guide to Finding Peace in a Frantic World*, Piatkus, 2011.

WEBSITES

On mindfulness in psychotherapy

Site of the University of Massachusetts Medical School Center for Mindfulness: www.umassmed.edu/cfm/index.aspx

Site of the University of Bangor, Wales, Centre for Mindfulness Research and Practice: www.bangor.ac.uk/mindfulness/

BIBLIOGRAPHY

Prelude

PRESENCE, NOT EMPTINESS

An excellent academic study on the way that Rembrandt guided the viewer's eye to different parts of his paintings: DiPaola, S., et al., "Rembrandt's Textural Agency: A Shared Perspective in Visual Art and Science," *Leonardo*, vol. 43, no. 2, April 2010, pp. 145–151.

Schama, S., *Rembrandt's Eyes*, Knopf, 1999.

Wallace, B. A., and S. L. Shapiro, "Mental Balance and Well-Being: Building Bridges Between Buddhism and Western Psychology," *American Psychologist*, vol. 61, October 2006, pp. 690–701.

1. Becoming aware

LIVE IN THE PRESENT MOMENT

Wildenstein, D., *Monet: Vie et oeuvre*, vol. 4, Lausanne, Bibliothèque des Arts, 1985.

Gunaratana, Bhante Henepola, *Mindfulness in Plain English*, Wisdom Publications, 1994.

INHABIT YOUR BODY

On Watteau's painting: Cheng, F., *Pélérinage au Louvre*, Paris, Flammarion, 2008.

Davidson, R. J., et al., "Alterations in Brain and Immune Function Produced by Mindfulness Meditation," *Psychosomatic Medicine*, vol. 65, July–August 2003, pp. 564–570.

Epel, E. S., J. Daubenmier, J. T. Moskowitz, S. Folkman, and E. H. Blackburn, "Can Meditation Slow Rate of Cellular Aging? Cognitive Stress, Mindfulness, and Telomeres," *Annals of the New York Academy of Sciences*, vol. 1172, August 2009, pp. 34–53.

Jacobs, T. L., et al., "Intensive Meditation Training. Immune Cell Telomerase Activity, and Psychological Mediators," *Psychoneuroendocrinology*, October 2010; DOI: 10.1016/j psyneuen. 20100.09.010.

CLOSE YOUR EYES AND LISTEN

The quotation from Yone Noguchi is taken from *Selected Poems of Yone Noguchi*, Nabu, 2010.

OBSERVE YOUR THOUGHTS

Searle, A., K. Scott, and C. Grenier, *Peter Doig*, London, Phaidon, 2006.

Ricard, M., *Happiness: A Guide to Developing Life's Most Important Skill*, Little, Brown, 2006.

MAKE SPACE FOR YOUR EMOTIONS

Brinkmann, B., *Cranach*, London, Royal Academy of Arts, 2008.

Raes, F., et al., "Mindfulness and Reduced Cognitive Reactivity to Sad Mood: Evidence from a Correlational Study and Non-Randomized Waiting List Controlled Study," *Behaviour Research and Therapy*, vol. 47, July 2009, pp. 623–627.

Farb, N. A. S., et al., "Minding One's Emotions: Mindfulness Training Alters the Neural Expression of Sadness," *Emotion*, vol. 10, February 2010, pp. 25–33.

USE YOUR ATTENTION TO EXPAND YOUR AWARENESS

Marijnissen, R. H., *Bosch*, Horizon, 1990.

Shabkar, *The Life of Shabkar: The Autobiography of a Tibetan Yogi*, trans. M. Ricard, Snow Lion, 2001. Also, *Rainbows Appear: Tibetan Poems of Shabkar*, Shambhala, 2002.

Recent fascinating studies on awareness include Christof Koch, *The Quest for Consciousness: A Neurobiological Approach*, Roberts & Co., 2004; Antonio Damasio, *Self Comes to Mind. Constructing the Conscious Brain*, Pantheon, 2010. For an accessible, rigorous overview, see Philippe Presles, *Tout ce qui n'intéressait*

pas Freud: L'éveil à la conscience et à ses mystérieux pouvoirs, Paris, Robert Laffont, 2011.

James, W., *The Principles of Psychology*, vol. 1, 1890, chap. 11, "Attention," pp. 403–404.

MacLean, K. A., et al., "Intensive Meditation Training Improves Perceptual Discrimination and Sustained Attention," *Psychological Science*, vol. 21, June 2010, pp. 829–839.

There are many studies on attention training in the treatment of anxiety and depression. A good example in French, focusing on the fear of blushing, is provided in Antoine Pelissolo and Stéphane Roy, *Ne plus rougir et accepter le regard des autres*, Paris, Odile Jacob, 2009.

On psychotoxic environments, see André, C., "Consommer moins pour exister mieux!," *Cerveau et Psycho* no. 36, May–June 2010, pp. 16–17.

BE SIMPLY PRESENT

Cuzin, J.-P., and D. Salmon, *Georges de La Tour, histoire d'une redécouverte*, Paris, Gallimard, "Découvertes" series, 1997.

Quignard, P., *Georges de La Tour*, Paris, Galilée, 2005; *La Nuit et le silence*, Paris, Flohic, 1995.

St. Augustine, *Confessions*, trans. E. B. Pusey, Gutenberg e-book.

Claudel, P., *Psaumes*, Paris, Téqui, 1986.

De Mello, A., *Sadhana—A Way to God*, Bantam Doubleday Dell, 1978.

Ignatius of Loyola, *The Spiritual Exercises of St. Ignatius: Based on Studies in the Language of the Autograph*, trans. L. J. Puhl, London, Loyola Press, 2012.

2. LIVING WITH THE EYES OF THE MIND WIDE OPEN

SEE THE INVISIBLE

Bott, G. C., *Still Life*, Cologne, Taschen, 2008.

Comte-Sponville, A., *Chardin, ou la matière heureuse*, Paris, Adam Biro, 1999.

Prigent, H., and P. Rosenberg, *Chardin: An Intimate Art*, Harry Abrams, 2000.

Schneider, N., *Still Life*, Taschen, 2003.

SEE WHAT IS IMPORTANT

The quotation on "short thoughts" is from Tiziano Terzani, *Le Grand Voyage de la vie. Un père raconte à son fils*, Paris, Le Seuil, "Points" series, 2009.

Thoreau, H. D., *The Journal of Henry David Thoreau, 1837–1861*, New York Review Books Classics, 2009; *Walden*, Everyman, 1910; *Life Without Principle*, available online, for example at: thoreau.eserver.org/lifewout.html

Cioran, E. M., *Notebooks*, Arcade, publication delayed indefinitely; Cahiers, Paris, Gallimard, 1997.

Des Forêts, L. R., *Pas à pas jusqu'au dernier*, Paris, Mercure de France, 2001.

On materialism: Kasser, T., *The High Price of Materialism*, Cambridge, MIT Press, 2002; Pelegrin-Genel, E., *Des souris dans un labyrinth. Décrypter les ruses et manipulations de nos espaces quotidiens*, Paris, La Découverte, 2010; Raynor, H. A., and L. H. Epstein, "Dietary Variety, Energy Regulation and Obesity," *Psychological Bulletin*, vol. 127, no. 3, May 2001, pp. 325–341; Schwartz, B., *The Paradox of Choice: Why More Is Less*, Harper, 2005.

De Foucauld, J.-B., *L'Abondance frugale. Pour une nouvelle solidarité*, Paris, Odile Jacob, 2010.

Websites combating materialism include:

www.commercialfreechildhood.org / www.simpleliving.net / http://simplicitevolontaire.info / www.bap.propagande.org

ACT AND DON'T ACT

Proudhon, *Du principe de l'art et de sa destination sociale*, 1865.

The quotation on stillness is from Jacques Castermane, *La Sagesse exercée*, Paris, La Table Ronde, 2005.

On the uses of action in psychotherapy:

For health professionals: Martell, C. R., et al., *Behavioral Activation for Depression: A Clinician's Guide*, Guilford Press, 2010.

For patients: Addis, M. E., and C. R. Martell, *Overcoming Depression One Step at a Time: The New Behavioral Activation Approach to Getting Your Life Back*, New Harbinger, 2004.

SHARPEN YOUR MIND

Buck, S., *Hans Holbein: Masters of German Art*, Konemann, 1999.

Moore, A., and P. Malinowski, "Meditation, Mindfulness and Cognitive Flexibility," *Consciousness and Cognition*, vol. 18, no. 1, March 2009, pp. 176–186.

Nielsen, L., and A. W. Kasziak, "Awareness of Subtle Emotional Feelings: A Comparison of Long-Term Meditators and Nonmeditators," *Emotion*, vol. 6, August 2006, pp. 392–405.

Piaget, J., *The Child's Conception of the World*, Rowman and Littlefield, 2007.

The quotation from Freud is taken from his book *A General Introduction to Psychoanalysis*, widely available free online, for example at: http://www.gutenberg.org/ebooks/38219

The quotation from Thich Nhat Hanh is from his book *The Miracle of Mindfulness*, trans. Mobi Ho, Rider Books, 1991.

The quotation from Simone Weil (and all the others that appear here) are from her book *Gravity and Grace*, trans. E. Arthur Wills, G. P. Putnam's Sons, 1952.

For a fuller exploration of Buddhist concepts: Khyentse Rinpoche, D., Patrul Rinpoche, *The Heart Treasure of the Enlightened Ones* (Foreword by the Dalai Lama), Shambhala, 1993; Nhat Hanh, T., *The Heart of Buddha's Teaching: Transforming Suffering into Peace, Joy and Liberation*, Rider, 1999; Midal, F., *ABC du bouddhisme. Apprendre à méditer, travailler sur soi, ouvrir son Coeur*, Paris, Grancher, 2008 (source of the quotation on the "mirage of reality"); Midal, F., *Quel bouddhisme pour l'Occident?*, Paris, Le Seuil, 2006.

UNDERSTAND AND ACCEPT WHAT IS

The quotation "It is not for you to accept things, they are already there" is taken from Prakash, S., *L'Expérience de l'unité. Dialogues avec Svâmi Prajnânpad*, Paris, Accarias L'Originel, 1986.

The quotation on wisdom and opponents is from Jonathan Haidt's book *The Happiness Hypothesis*, Arrow, 2006.

Books offering a deeper understanding of acceptance: Comte-Sponville, A., *De l'autre côté du désespoir. Introduction à la pensée de Svâmi Prajnânpad*, Paris, Accarias L'Originel, 1997; Castermane, J., *La Sagesse exercée, op. cit.*; Krishnamurti, *Freedom from the Known*, Rider Books, 2010; Prakash, S., *L'Expérience de l'unité. Dialogues avec Svâmi Prajnânpad*, Paris, *op. cit.*

3. PASSING THROUGH STORMS

ESCAPE YOUR MENTAL PRISONS

On pain: the modifications observed in experienced practitioners of Zen meditation include thickening of the cortex, notably in the anterior cingulate cortex and the somatosensory cortex, which are involved in the perception of pain. Grant, J. A., et al., "Cortical Thickness and Pain Sensitivity in Zen Meditators," *Emotion*, vol. 10, no.1, February 2010, pp. 43–53; Speca, M., et al., "A Randomized, Wait-List Controlled Trial: The Effect of Mindfulness Meditation-Based Stress Reduction Program on Mood and Symptoms of Stress in Cancer Outpatients," *Psychosomatic Medicine*, vol. 62, September–October 2000, pp. 613–622; Morone, N. E., et al., "Mindfulness Meditation for the Treatment of the Chronic Low Back Pain in Older Adults," *Pain*, vol. 134, no. 3, February 2008, pp. 310–319.

On modifications to the brain linked to mindfulness practice: Luders, E., et al., "The Underlying Anatomical Correlates of Long-Term Meditation: Larger Hippocampal and Frontal Volumes of Grey Matter," *NeuroImage*, vol. 45, April 2009, pp. 672–678; Lutz, A., et al., "Long-Term Meditators Self-Induce High-Amplitude Gamma Synchrony During Mental Practice," *PNAS*, vol. 101, no. 46, November 2004, pp. 16369–16373; Rubia, K., "The Neurobiology of Meditation

and Its Clinical Effectiveness in Psychiatric Disorders," *Biological Psychology*, vol. 82, no. 1, September 2009, pp. 1–11.

The quotation on prison bars is from Alexandre Jollien's book *Le Philosophe nu*, Paris, Le Seuil, 2010.

On rumination, for health professionals see Papageorgiou, C., and A. Wells (eds.), *Depressive Rumination*, John Wiley, 2004; Davey, G. C. L., and A. Wells (eds.), *Worry and Its Psychological Disorders*, John Wiley, 2006.

LET GO

Lemoine, S. (ed.), *From Puvis de Chavannes to Matisse and Picasso*, Bompiani, 2002.

STAY PRESENT TO THE WORLD

Marijnissen, R.-H., *Bruegel. Tout l'oeuvre peint et dessiné*, Paris, Éditions Charles Moreau, 2003.

MOVE FORWARD, EVEN WHEN YOU ARE HURT

For health professionals, some classic and recent studies on the use of mindfulness in the treatment of anxiety and depression: Teasdale, J. D., et al., "Prevention of Relapse/Recurrence in Major Depression by Mindfulness-Based Cognitive Therapy," *Journal of Consulting and Clinical Psychology*, vol. 68, no. 4, August 2000; Kuyken, W., et al., "Mindfulness-Based Cognitive Therapy to Prevent Relapse in Recurrent Depression," *Journal of Consulting and Clinical Psychology*, vol. 76, no. 6, December 2008, pp. 966–978; Segal, Z., et al., "Antidepressant Monotherapy Versus Sequential Pharmacotherapy and Mindfulness-Based Cognitive Therapy, or Placebo, for Relapse Prophylaxis in Recurrent Depression," *Archives of General Psychiatry*, 2010; Barnhofer, T., et al., "Mindfulness-Based Cognitive Therapy as a Treatment for Chronic Depression: A Preliminary Study," *Behaviour Research and Therapy*, vol. 47, no. 5, May 2009, pp. 366–373; Kenny, M., and J. M. G. Williams, "Treatment-Resistant Depressed Patients Show a Good Response to Mindfulness-Based Cognitive Therapy," *Behaviour Research and Therapy*, vol. 45, no. 3, March 2007, pp. 617–625.

And to readers who are not health professionals, we would say that, at the present time there is not enough evidence to show that any form of meditation can be regarded as a treatment for mental illness (or any other form of illness). On the other hand, it has shown itself to be a good tool in the prevention of relapses, in other words for remaining as well as possible, taking into account individual fragilities and histories. If you or someone close to you suffers from a psychiatric illness, meditation can help you, but it won't cure you.

Berghmans, C., et al., "*La méditation comme un outil psychothérapeutique complémentaire: une revue de question,*" *Journal de thérapie comportementale et cognitive*, vol. 19, no. 4, December 2009, pp. 120–135.

ACCEPT MYSTERY

Hood, W., *Fra Angelico at San Marco*, New Haven, Yale University Press, 1993.

Spike, J., *Fra Angelico*, New York, Abbeville, 1997.

The quotation from Viktor Frankl is taken from Tzvetan Todorov's excellent book *Face à l'extrême*, Paris, Le Seuil, "Points" series, 1994, p. 99.

See also Viktor Frankl, *Man's Search for Meaning*, Rider Books, 2004.

Phillips, A., *On Balance*, Farrar, Straus and Giroux, 2010.

The hidden stars metaphor is borrowed from André Comte-Sponville in *The Book of Atheist Spirituality*, trans. N. Houston, Bantam, 2007.

SEE HAPPINESS GENTLY EMERGE

André, C., *Les États d'âme. Un apprentissage de la sérénité*, Paris, Odile Jacob, 2009.

For a greater understanding of the Chinese vision of happiness: Dan, Y., *Confucius from the Heart: Ancient Wisdom for Today's World*, trans. E. Tyldesley, Macmillan, 2009; Jullien, F., *Vital Nourishment: Departing from Happiness*, trans. A. Goldhammer, Zone Books, 2007.

The quotation from Camus on happiness and awareness is taken from *L'Envers et l'endroit*, Paris, Gallimard, "Folio essais" series, no. 41, p. 118.

The quotation from Etty Hillesum is from *Etty*, trans. A. J. Pomerans, Wm. B. Eerdmans, 2002, p. 461.

The quotation from Eugenia Ginzburg is from *Journey Into the Whirlwind*, trans. P. Stevenson and M. Hayward, Mariner Books, 2002, p. 170.

Wood, A. M., and S. Joseph, "The Absence of Positive Psychological (Eudemonic) Well-Being as a Risk Factor for Depression: A Ten Year Cohort Study," *Journal of Affective Disorders*, vol. 122, no. 3, May 2010, pp. 213–217.

Brown, K. W., and R. M. Ryan, "The Benefits of Being Present: Mindfulness and Its Role in Psychological Well-Being," *Journal of Personality and Social Psychology*, vol. 84, no. 4, April 2003, pp. 822–884.

4. OPENING AND AWAKENING

WORK

Perec, G., *Species of Spaces and Other Pieces*, trans. J. Sturrock, Penguin, 1997.

Barbera, G., *Antonello da Messina: Sicily's Renaissance Master*, Metropolitan Museum of Art, 2013.

Zundel, M., *Vie, mort, résurrection*, Montreal, Éditions Anne Sigier, 2001.

The "mindfulness bell" is sounded at the famous Plum Village, founded by Thich Nhat Hanh. For more information visit: http://plumvillage.org

CONTEMPLATE

Hofmann, W., *Caspar David Friedrich*, trans. M. Whittall, Thames & Hudson, 2006.

The quotation from André Comte-Sponville is from his *Dictionnaire philosophique*, Paris, Presses Universitaires de France, 2001.

Dictionnaire des mots de la foi chrétienne, Paris, Les Éditions du Cerf, 1989.

The quotation from Christian Bobin is from one of his columns for *Le Monde des religions: "Le prophète au soufflé d'or,"* May–June 2010.

Jossua, J.-P., *Seul avec Dieu. L'aventure mystique*, Paris, Gallimard, "Découvertes" series, 1996.

Panikkar, R., *Le Silence du Bouddha. Une introduction à l'athéisme religieux*, Arles, Actes Sud, 2006.

On connecting with nature and biophilia: *An Ecology of Happiness*, trans. T. L. Fagan, University of Chicago Press, 2012.

LOVE

Simeon's words to Mary are in Luke 2: 34–35.

Roscam Abbing, M., *The Treasures of Rembrandt*, Carlton Books, 2014.

Meditations on altruistic love are discussed in detail in Ricard, M., *The Art of Meditation*, Atlantic Books, 2010, available as a Kindle e-book.

For an overview of the use of compassion in psychotherapy, see Gilbert, P., *Compassion Focused Therapy*, Routledge, 2010; Gilbert, P. (ed.), *Compassion. Conceptualisations, Research and Use in Psychotherapy*, Routledge, 2005; and this original study showing that altruistic meditation improves connections with others: Hutcherson, C. A., et al., "Loving-Kindness Meditation Increases Social Connectedness," *Emotion*, vol. 8, no. 5, October 2008, pp. 720–724.

**EXPERIENCE THE EXPANSION
AND DISSOLUTION OF THE SELF**

Paquet, M., *René Magritte, 1898–1967: Thought Rendered Visible*, Taschen, 1994.

Gohr, S., *Magritte: Attempting the Impossible,* D.A.P./Distributed Art Publishers, Inc., 2009.

Sylvester, D., *Magritte*, Thames & Hudson, 1992.

Meuris, J., *René Magritte*, Taschen, 2007.

Teilhard de Chardin, *The Phenomenon of Man*, trans. B. Wall, Wm. Collins Sons & Co., 1959.

The quotation "Abandon everything, abandon all that you know . . ." is from Tiziano Terzani, *Le Grand Voyage de la vie*, op. cit.

Comte-Sponville, A., *The Book of Atheist Spirituality*, op. cit.

Lenoir, F., and Y. Tardan-Masquelier, *Le Livre des sagesses. L'aventure spirituelle de l'humanité*, Paris, Bayard, 2005.

One study (among others) showing how a great deal of psychological pain is linked to excessive focus on the self: Way, B. M., et al., "Dispositional Mindfulness and Depressive Symptomatology: Correlations with Limbic and Self-Referential Neural Activity During Rest," *Emotion*, vol. 10, no. 1, February 2010, pp. 12–24.

UNIVERSAL AWARENESS

Büttner, N., *Landscape Painting: A History*, Abbeville, 2006.

ACKNOWLEDGMENTS

Thanks to Sophie de Sivry for her unconditional support, sharp eye and sensitivity. She brought beauty to this book, making it a work of art in itself. If it delights your eye, that's her work.

Thanks to Catherine Meyer for her friendship and availability, intuition and advice. She encouraged me to write in the most precise and evocative way possible. If this book touches and speaks to you, that's her work.

To both, thanks for giving me the means and time necessary to design and write this book.

Thank you for all this, and for all the rest.

PHOTO CREDITS